HAND DRAWN BY

SASKJA COOK

What better way to relax than to colour.
Whether you're looking for a way to unwind or a new hobby, colour therapy has been proven to be an effective stress management technique.

I love to draw and I love to see my pieces brought to life by each colourists unique take on them. Each piece is a collaboration between us, my drawing and your colouring.

Please feel free to share any finished pieces on:

www.facebook.com/sassycolouring

Copyright © Saskja Cook 2019. All rights reserved. No part of this book may be reproduced, stored in a retrieval system, or transmitted in any form or by any means, without the prior permission in writing from the author, nor be otherwise circulated in any other form of binding or cover other than that in which it is published and without a similar condition including this condition being imposed on the subsequent purchase

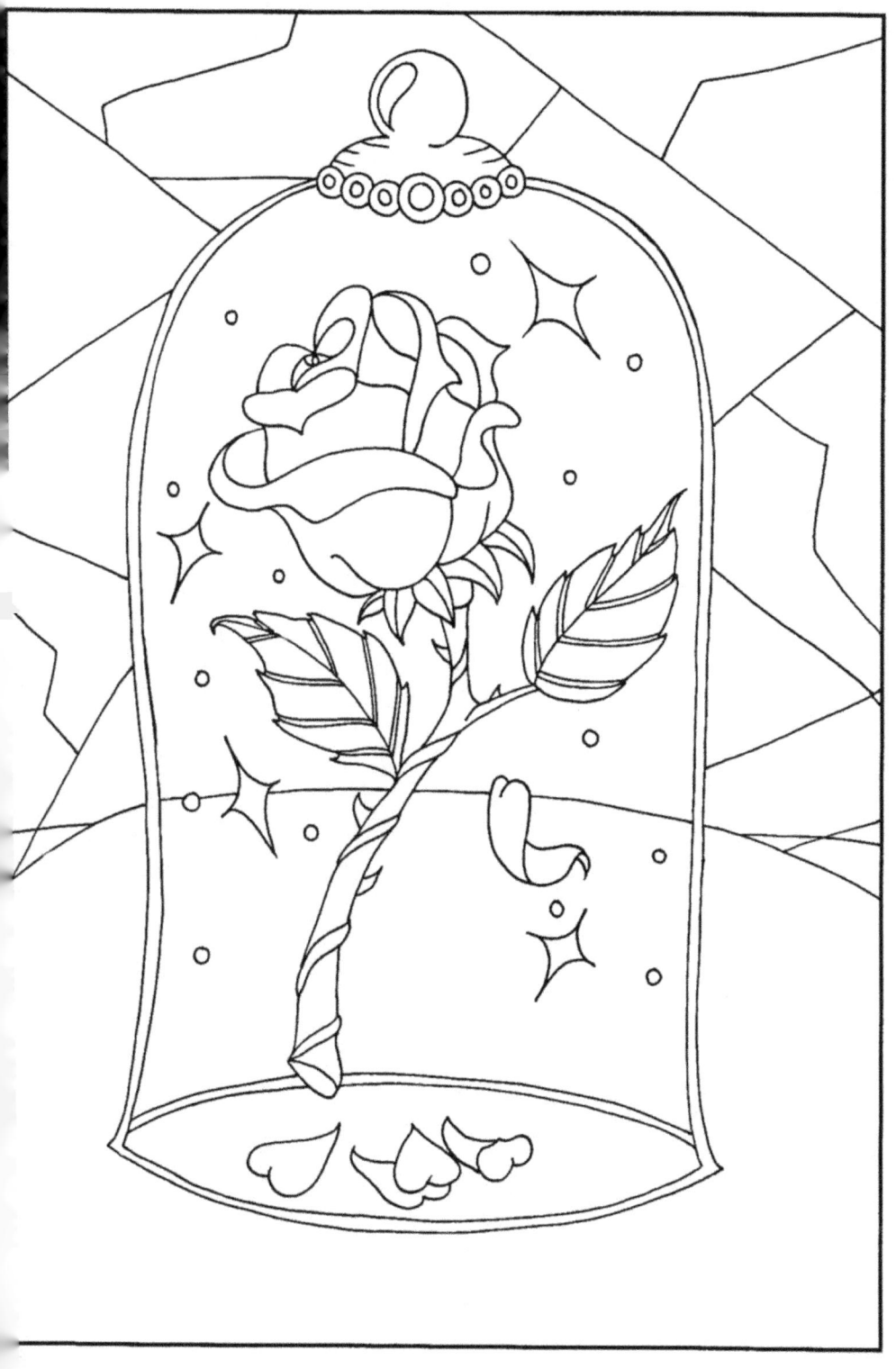

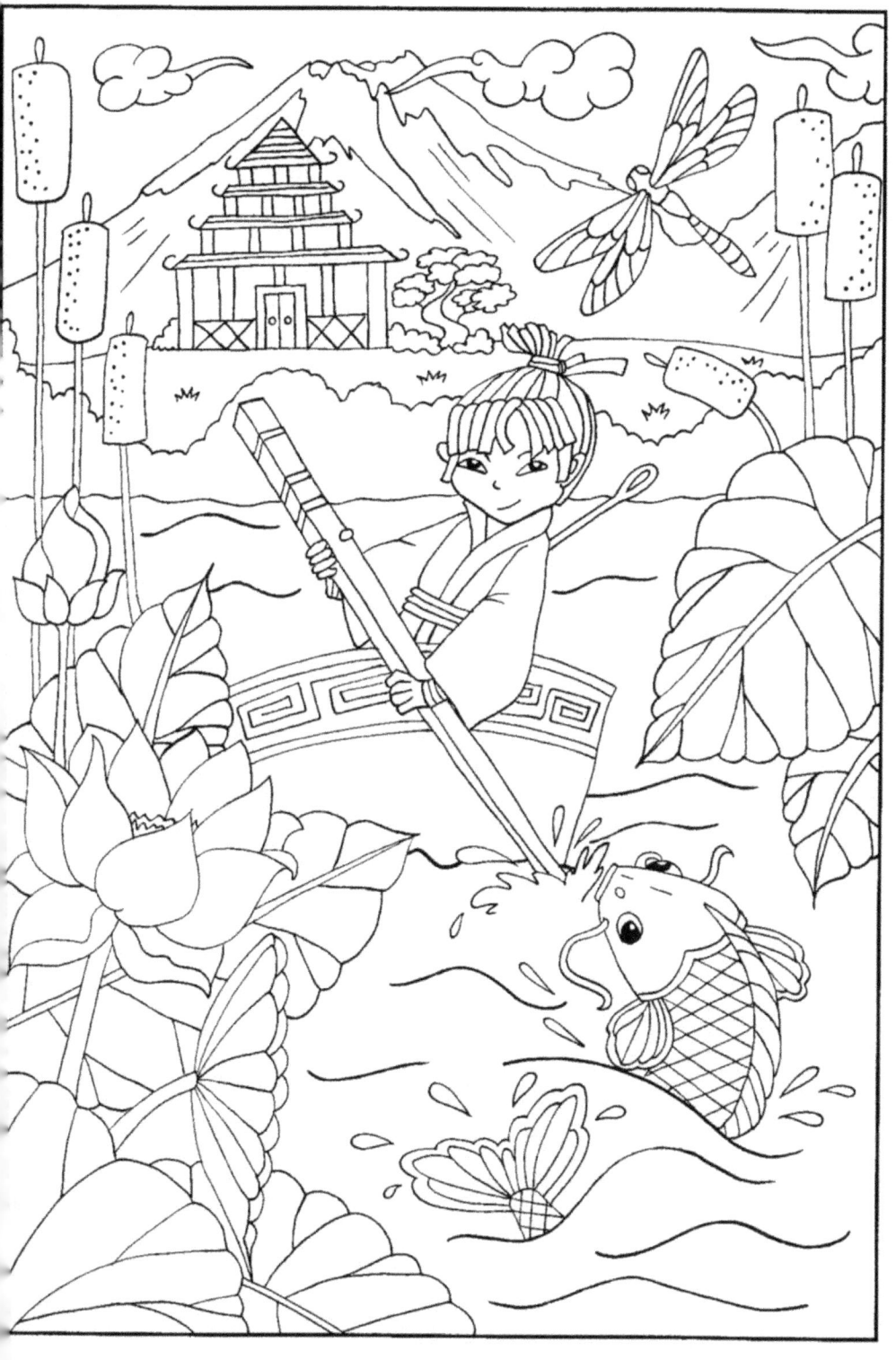

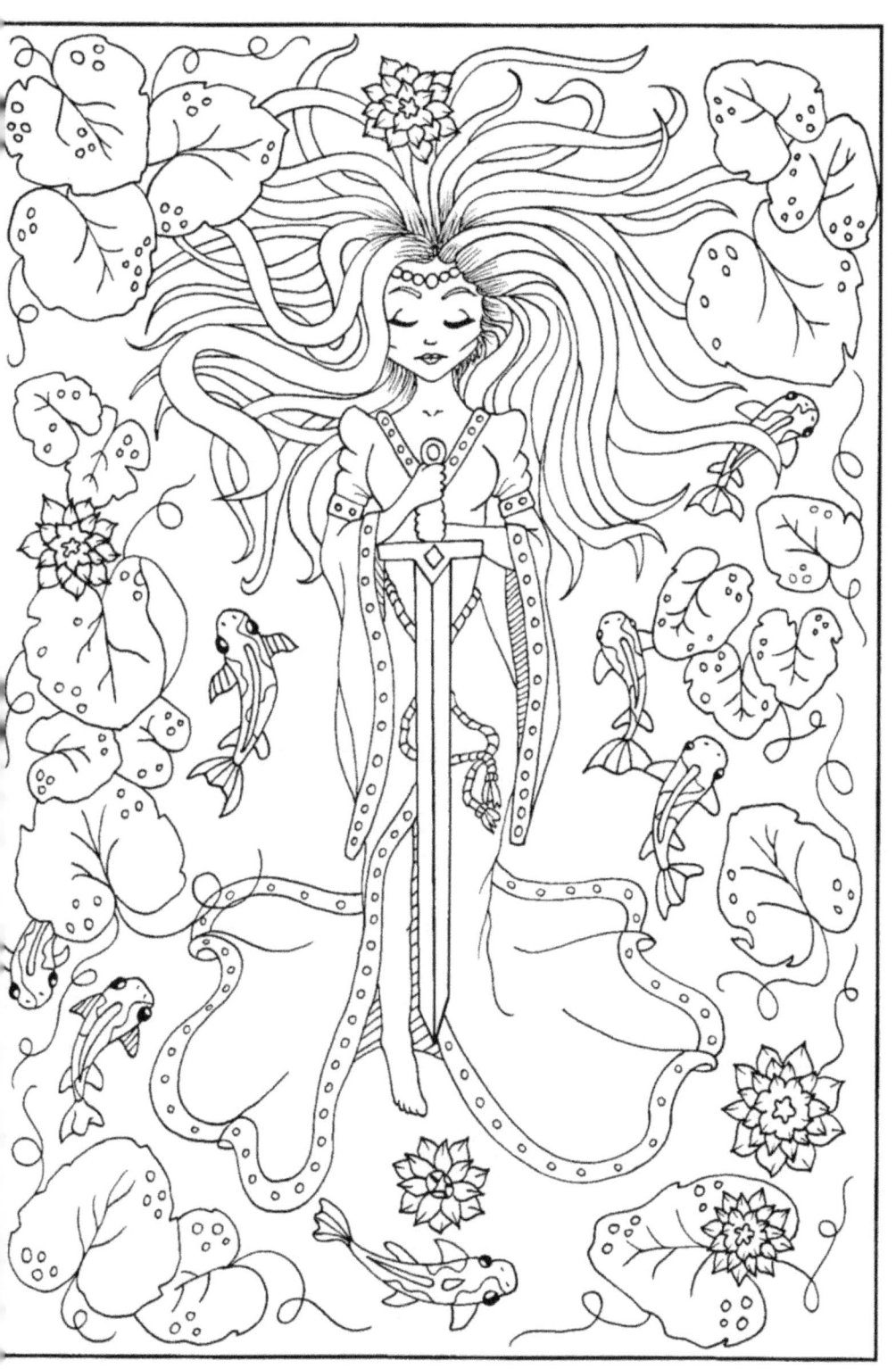

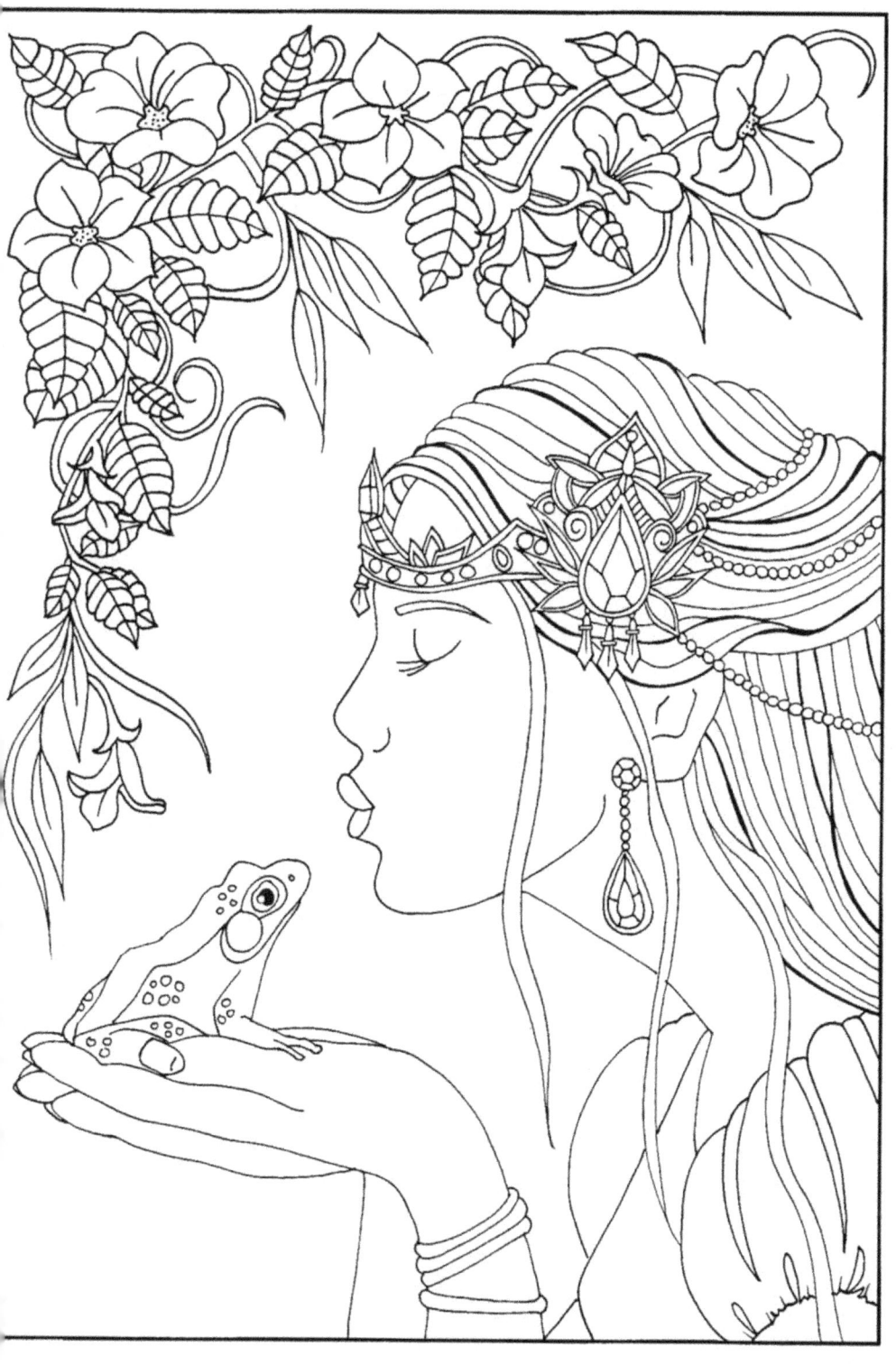

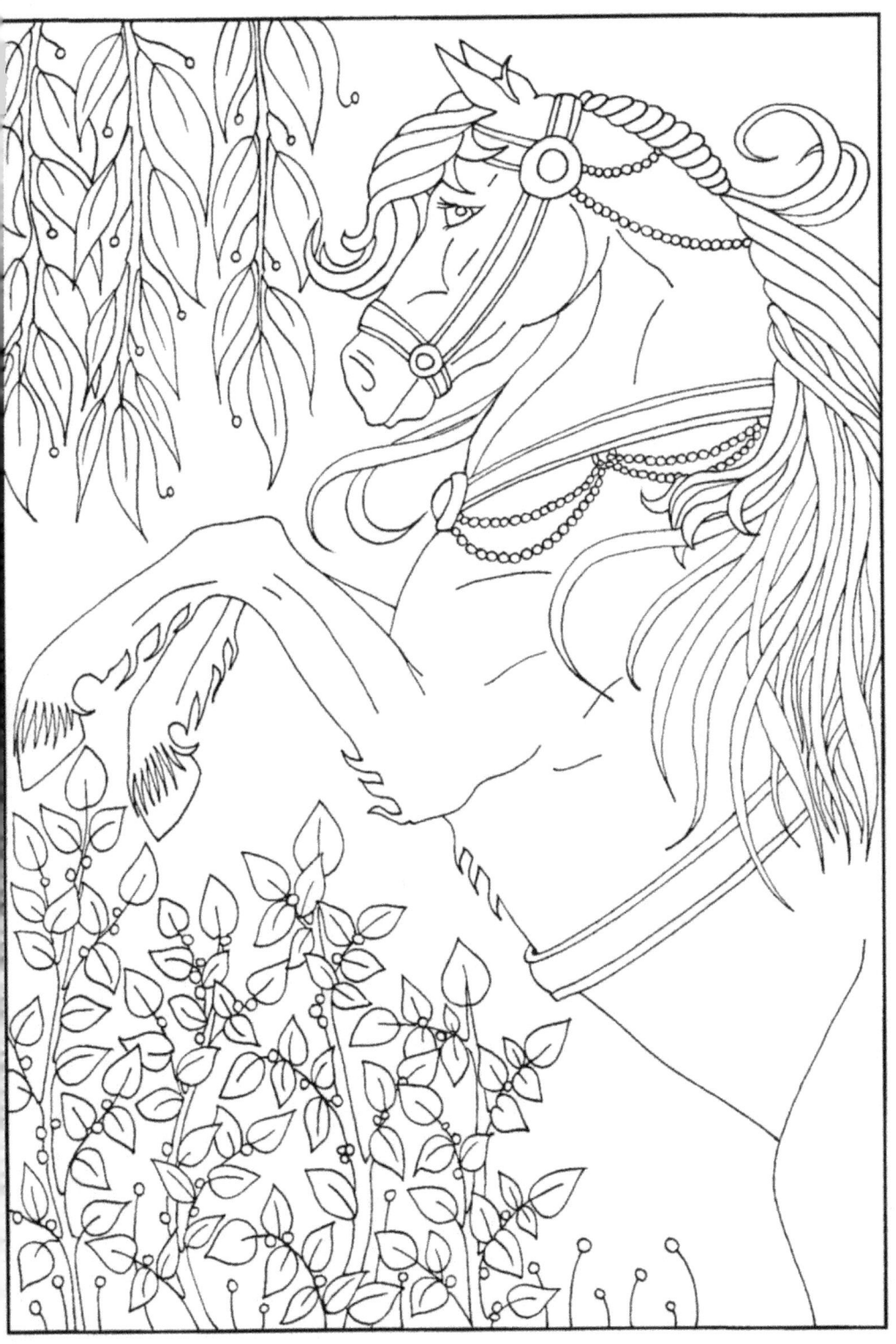

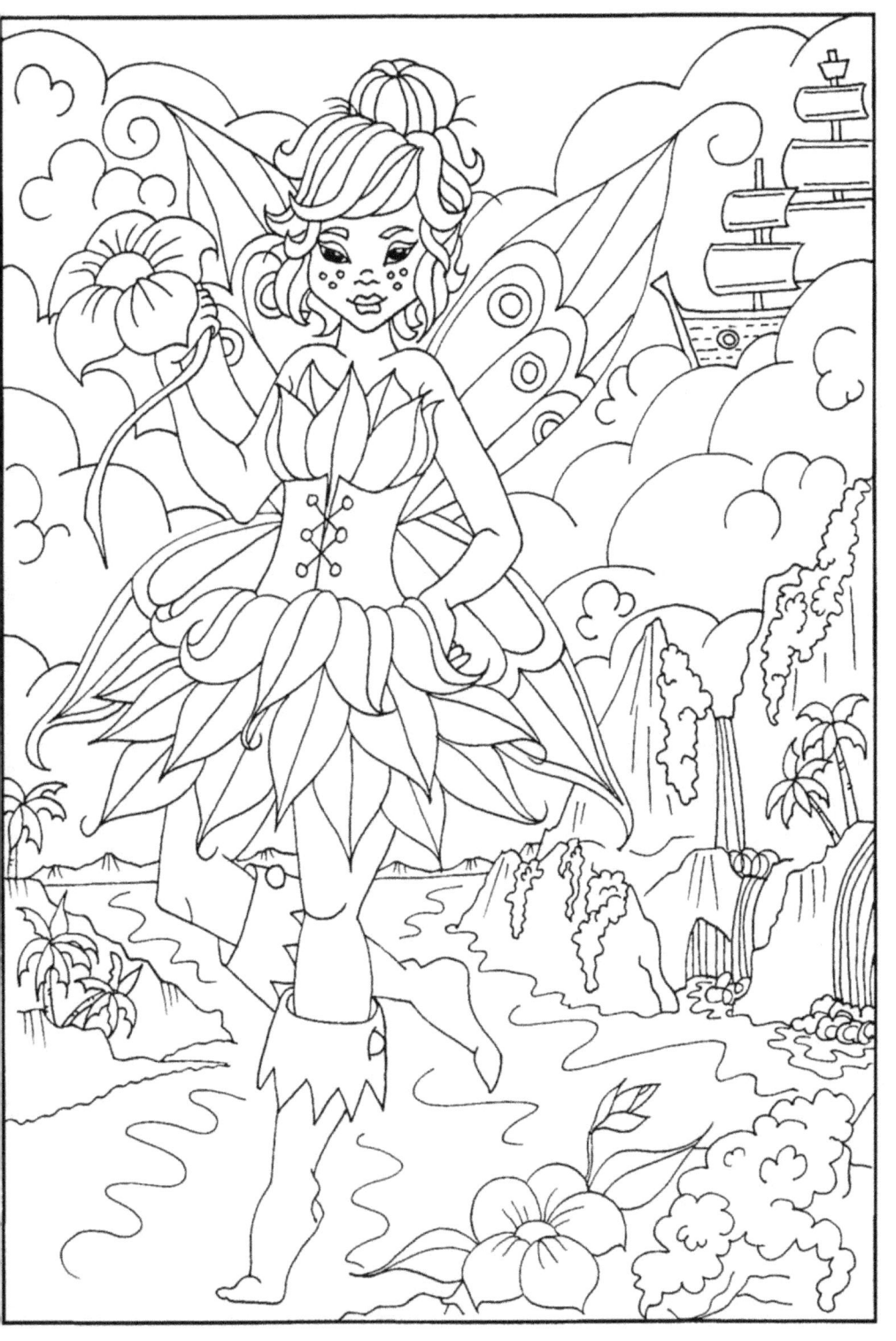

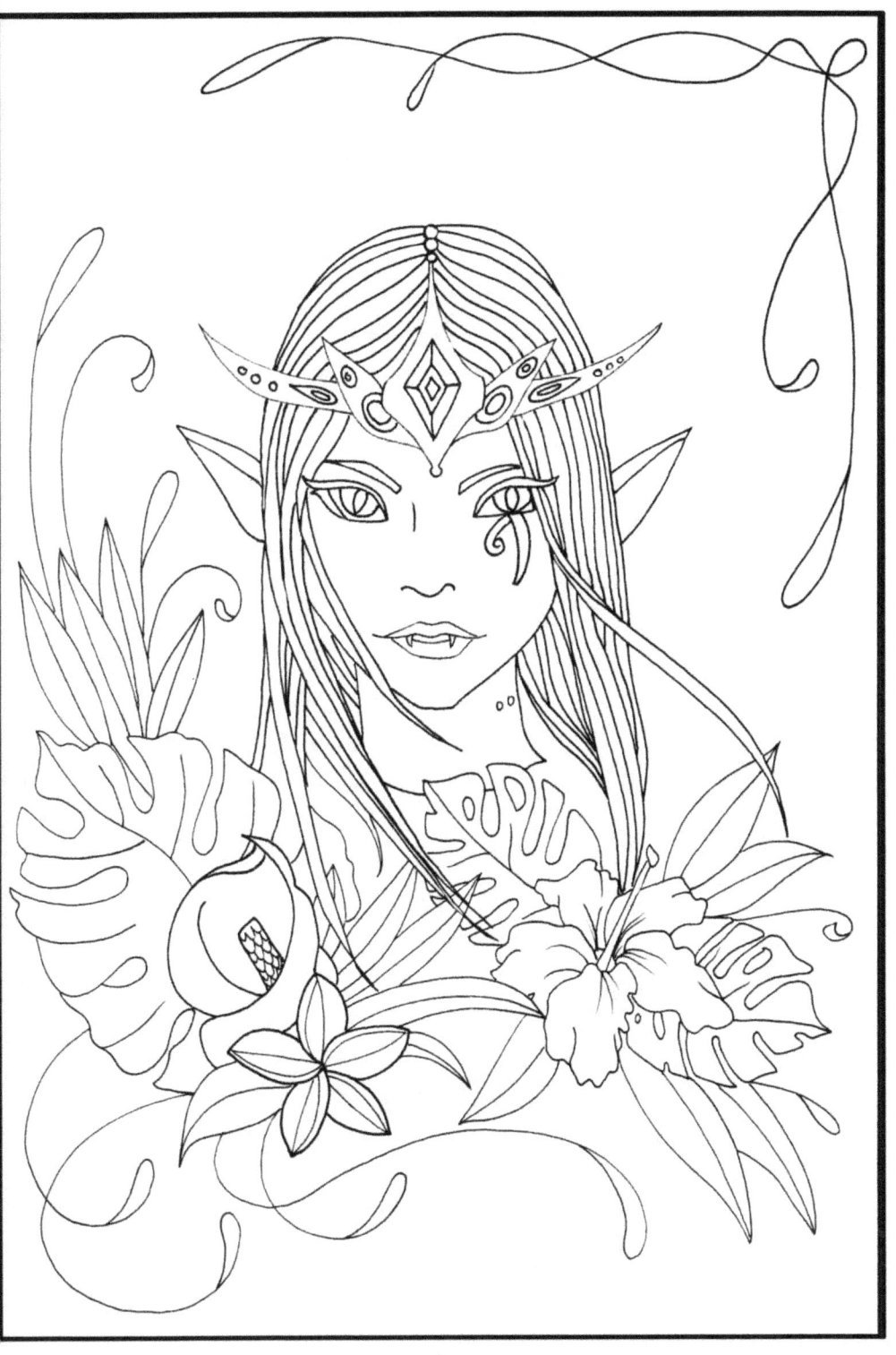

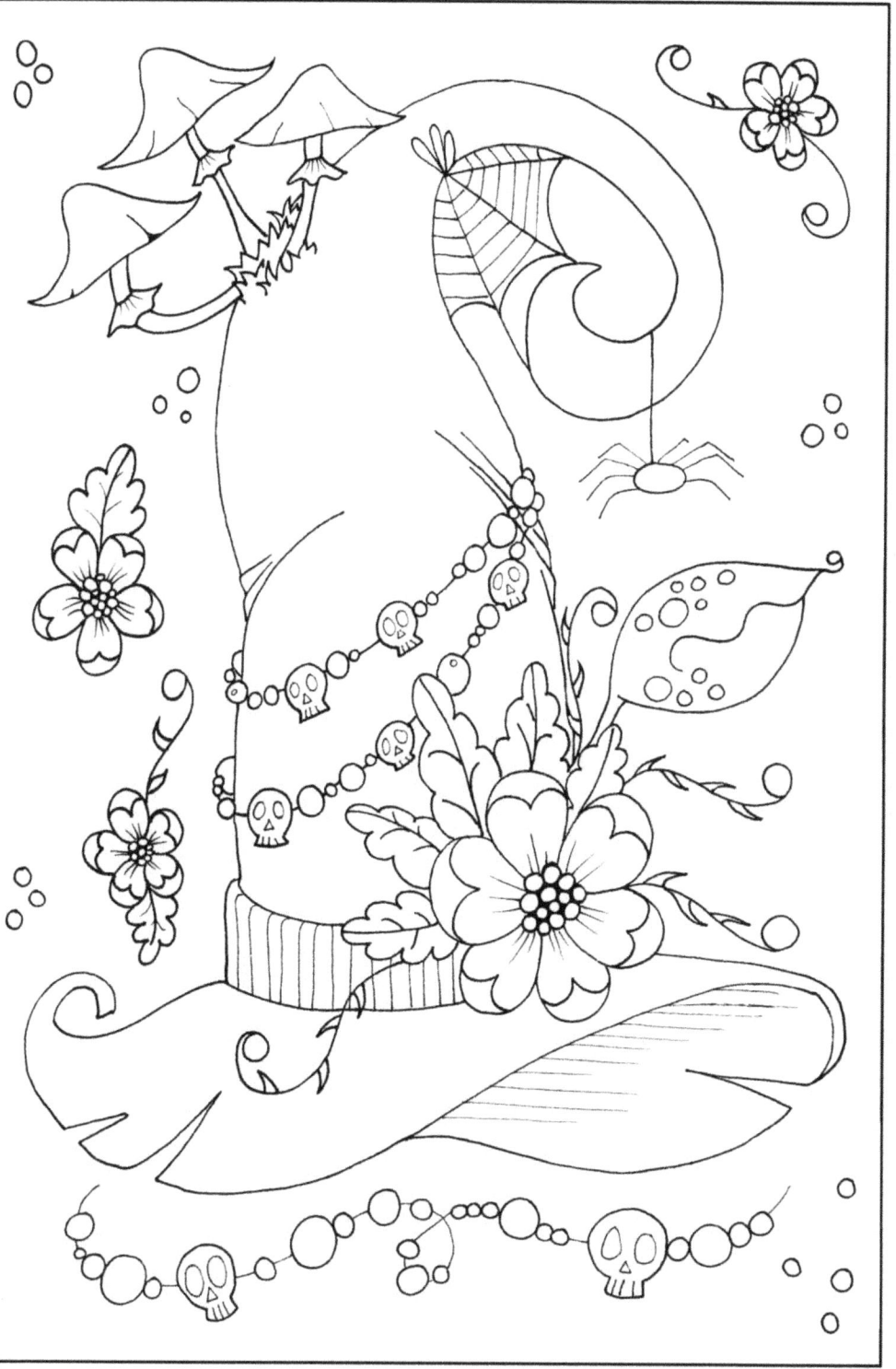

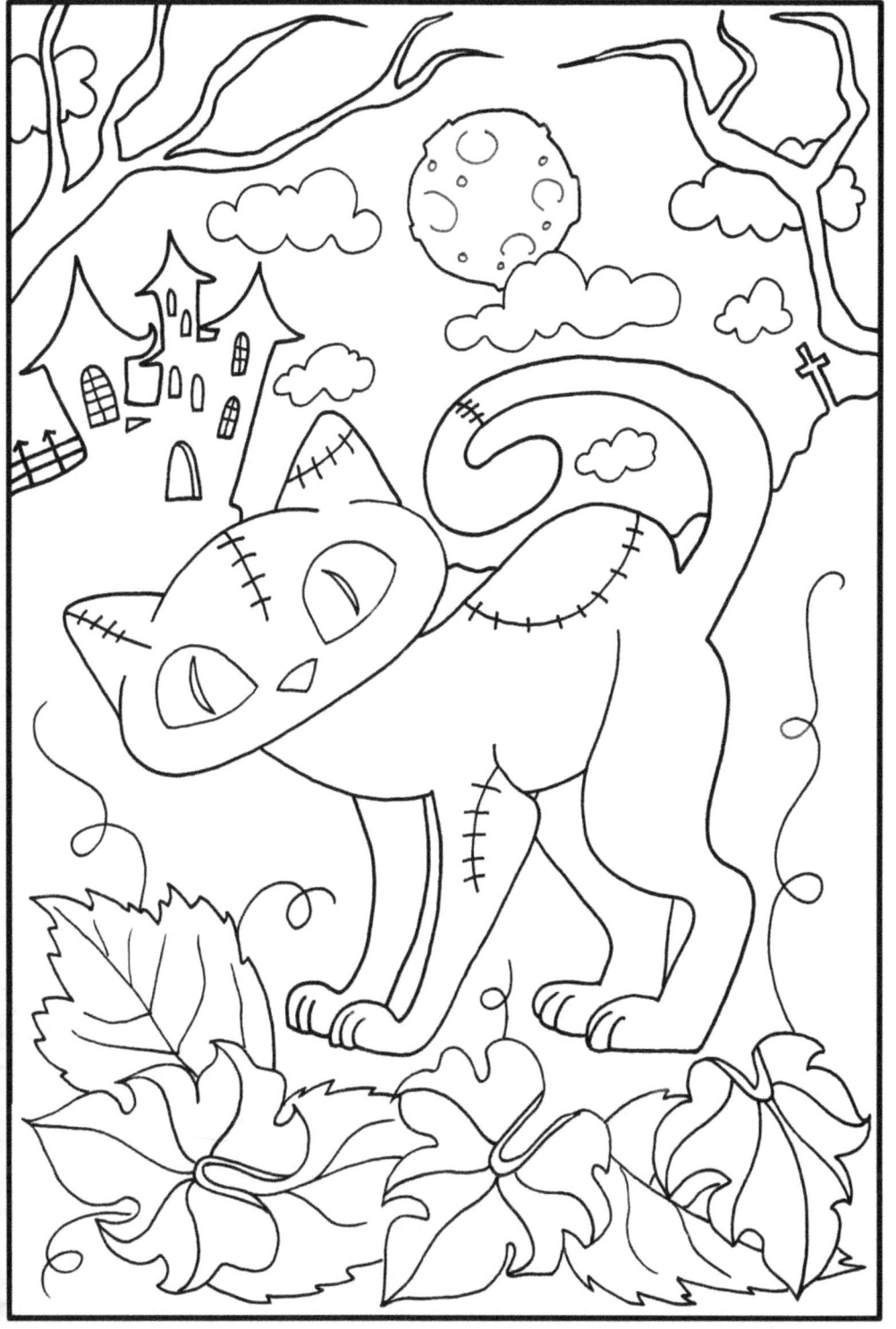

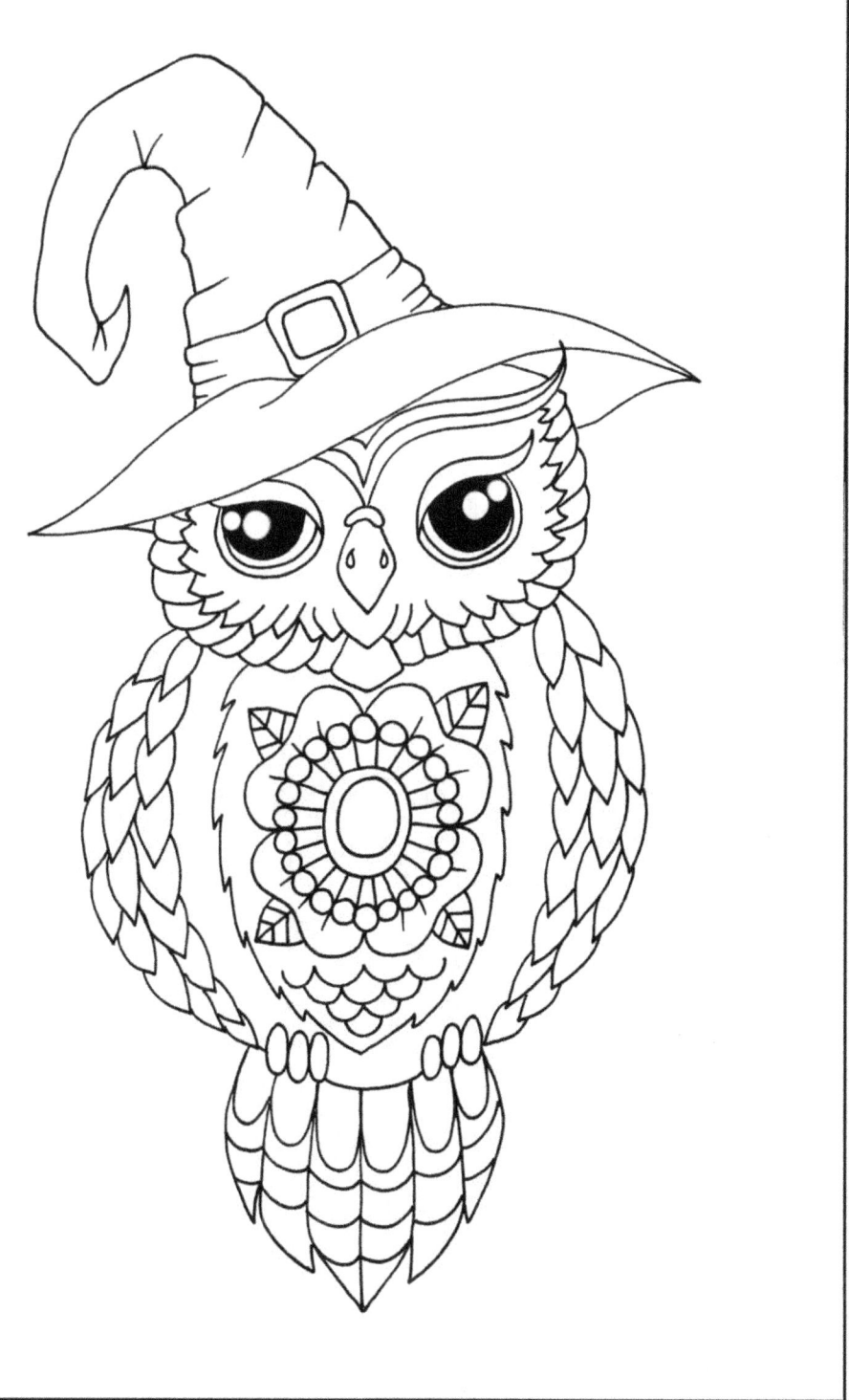

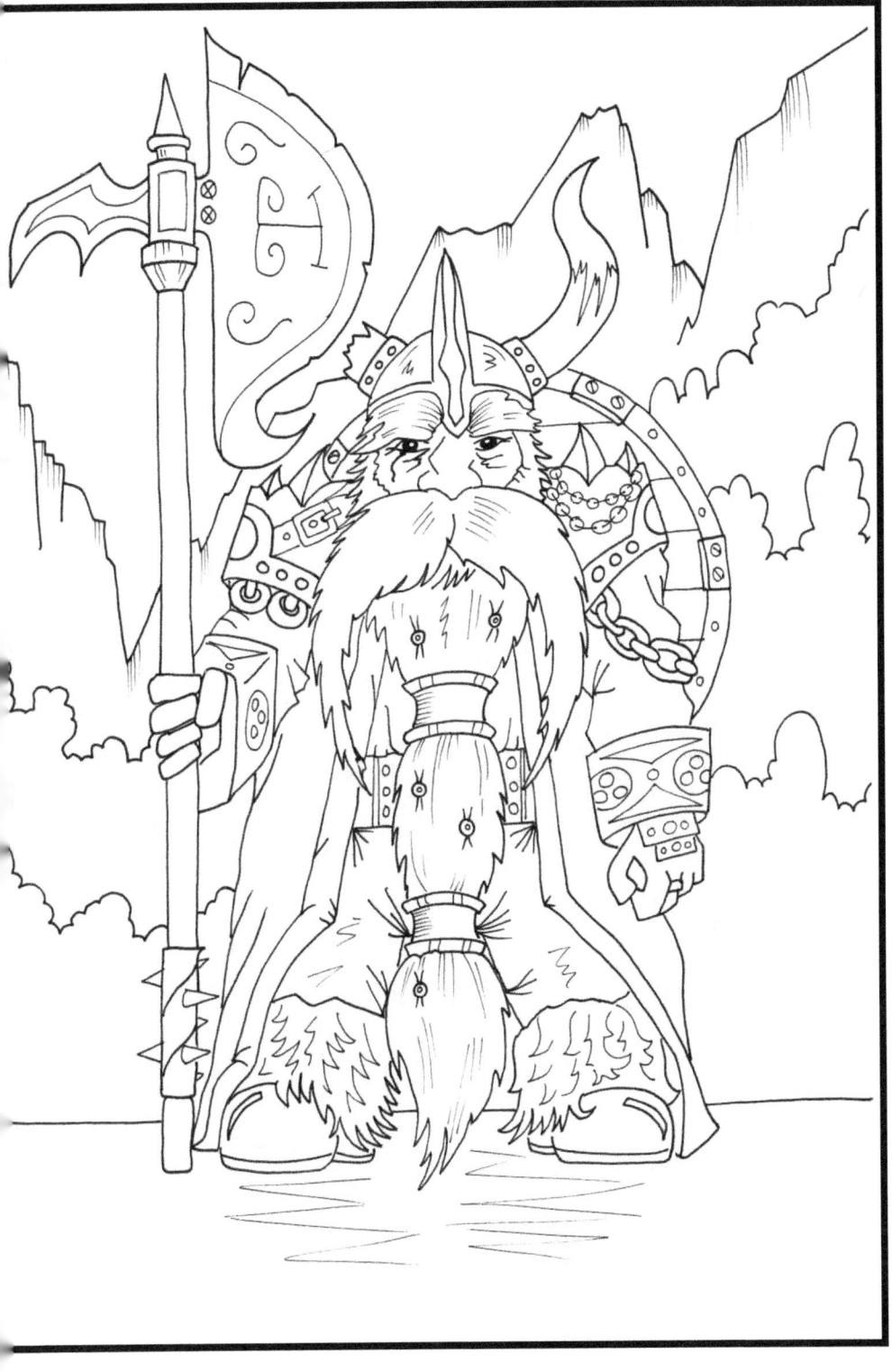

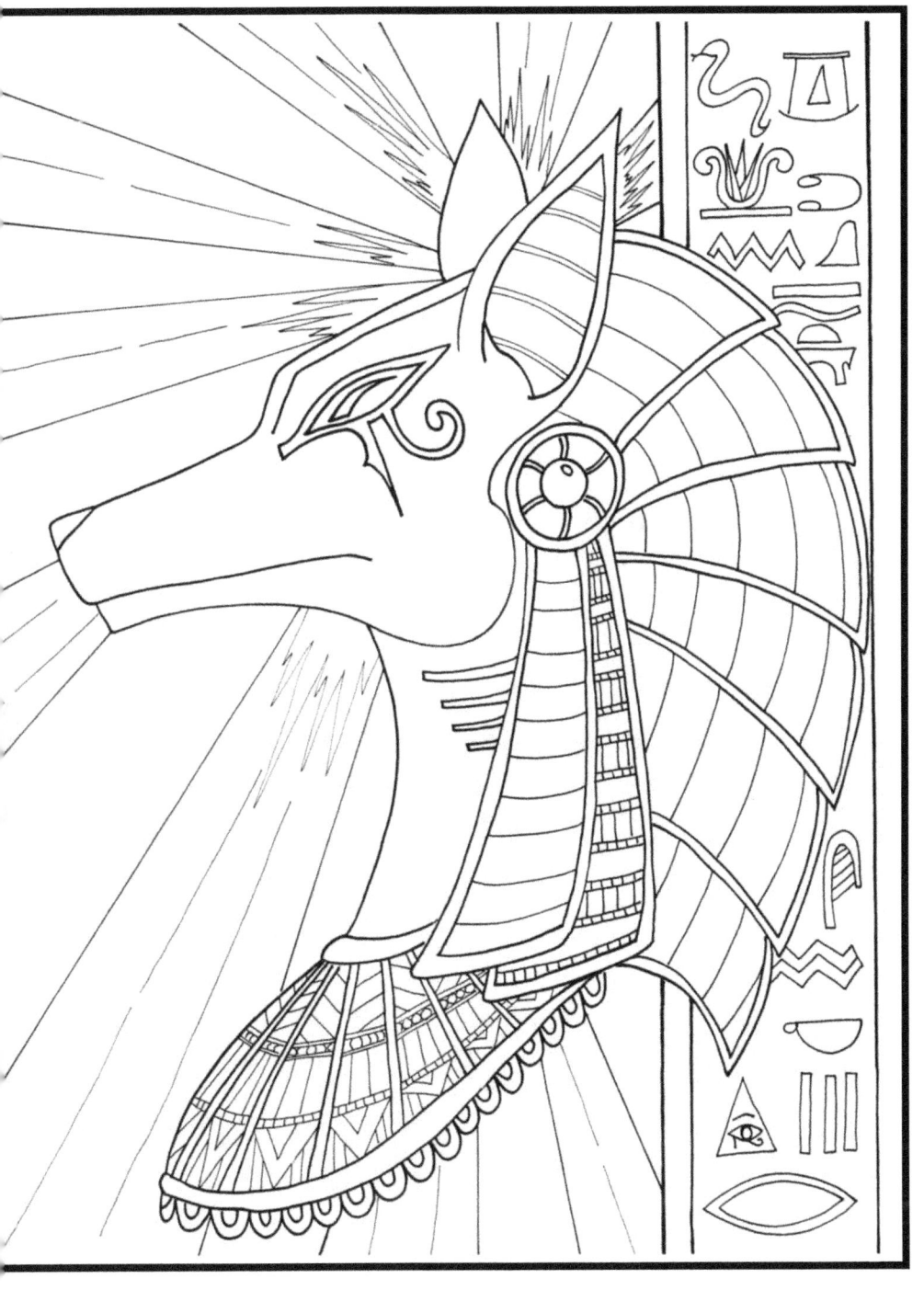

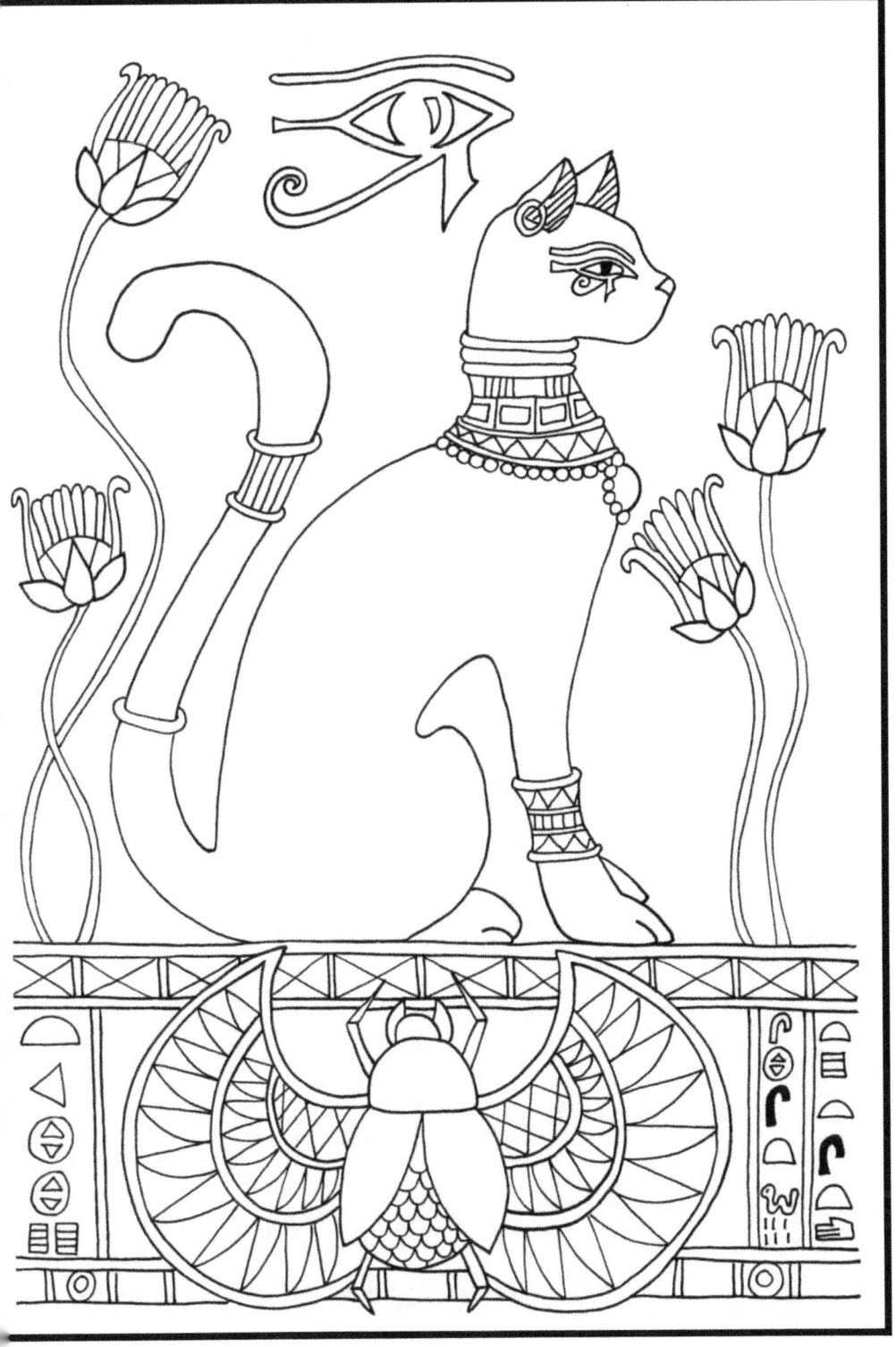

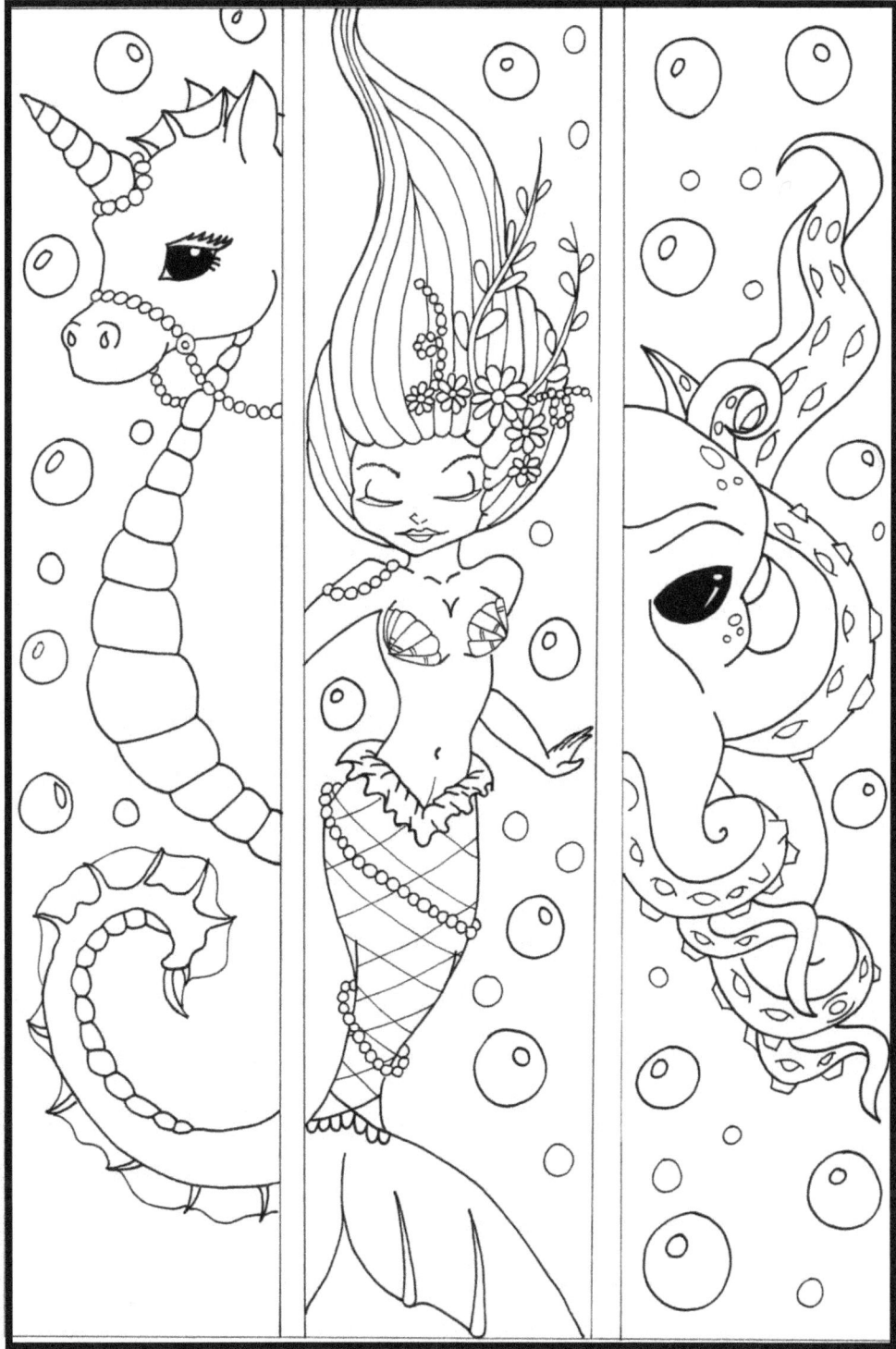

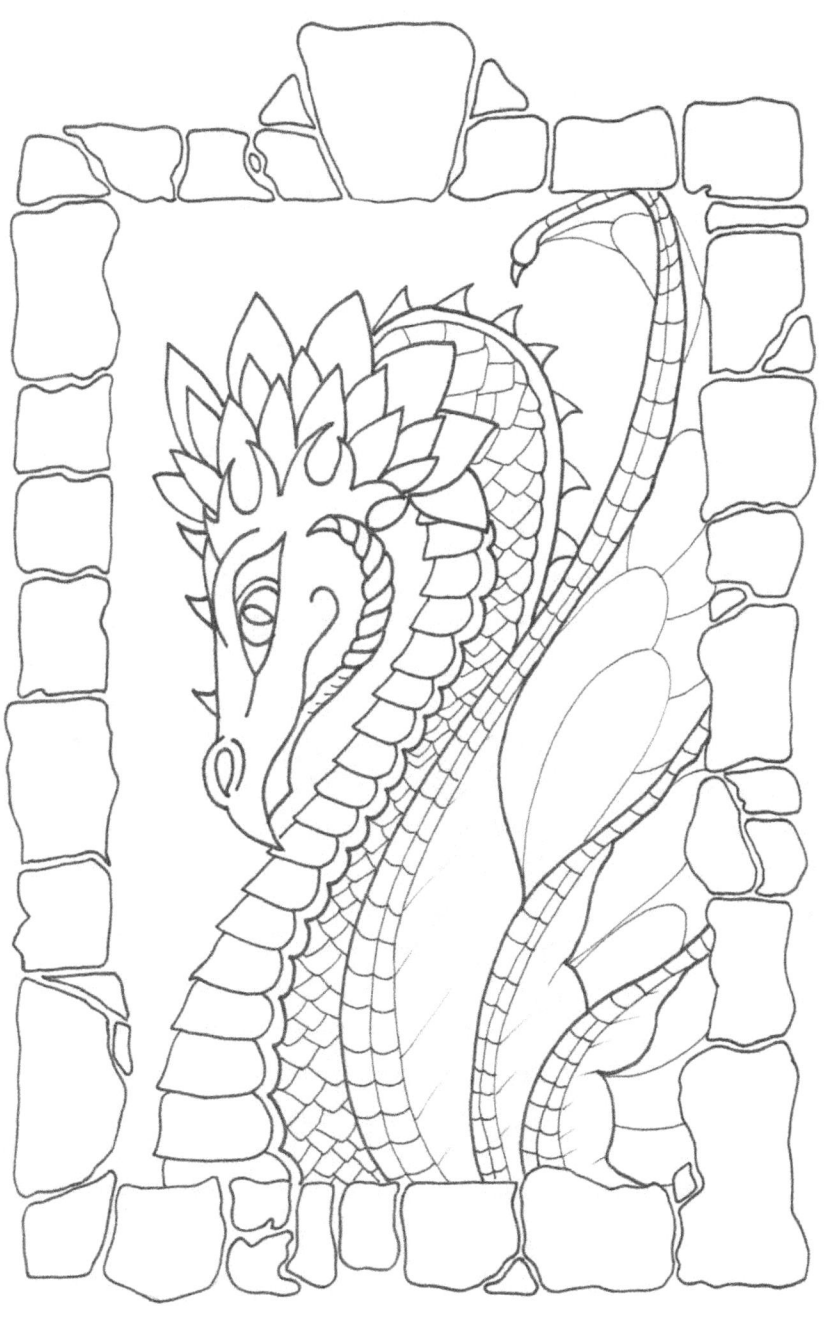

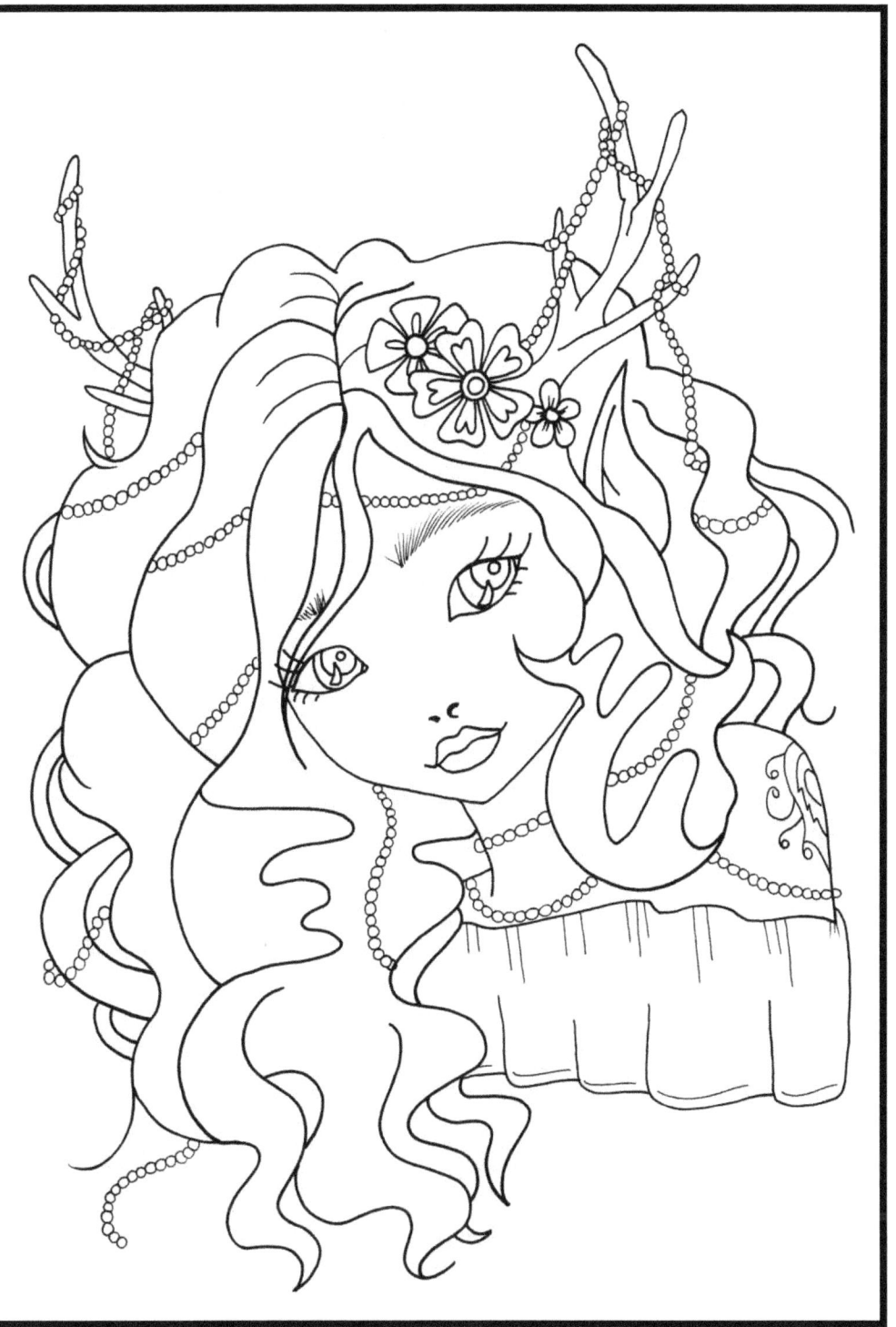

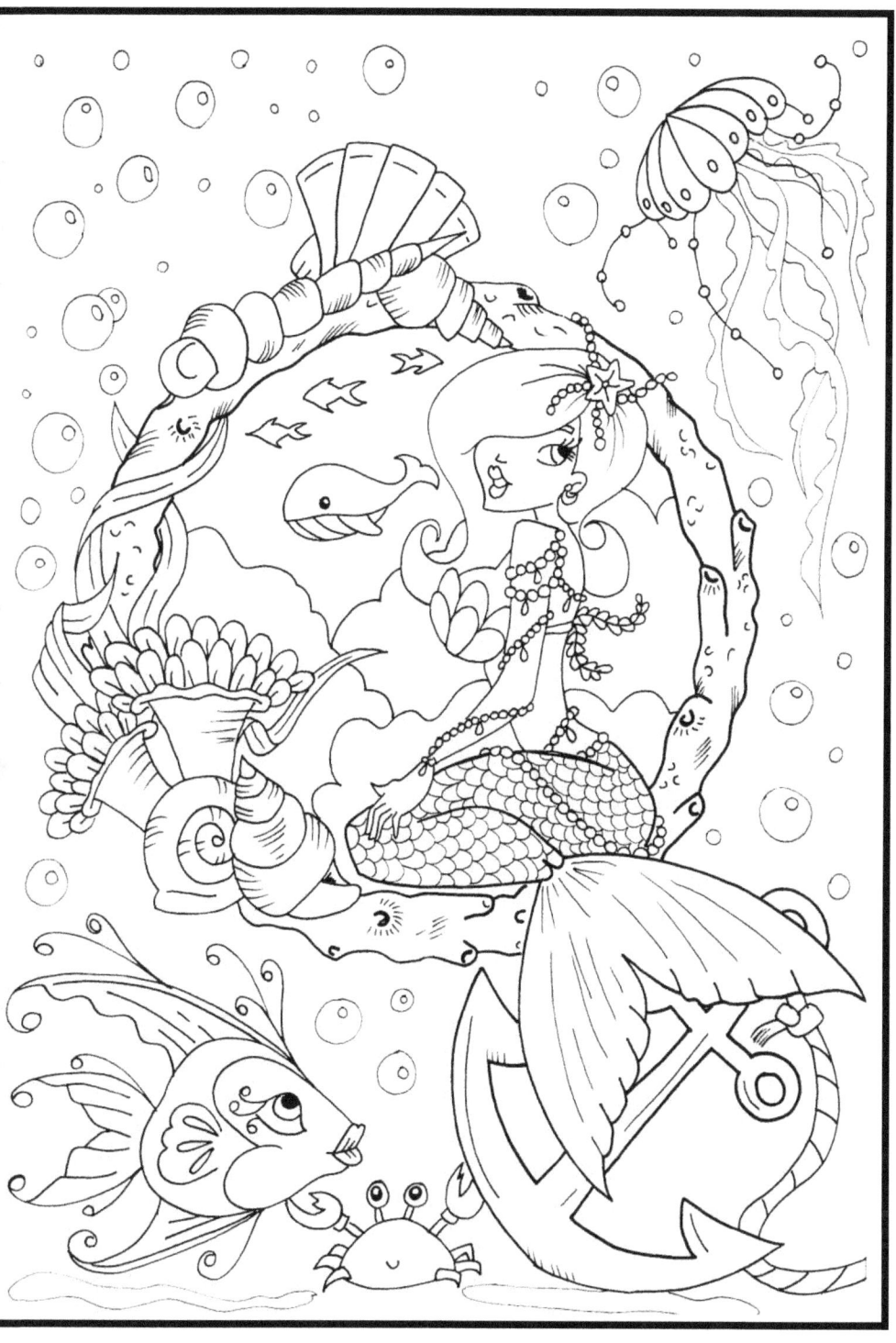

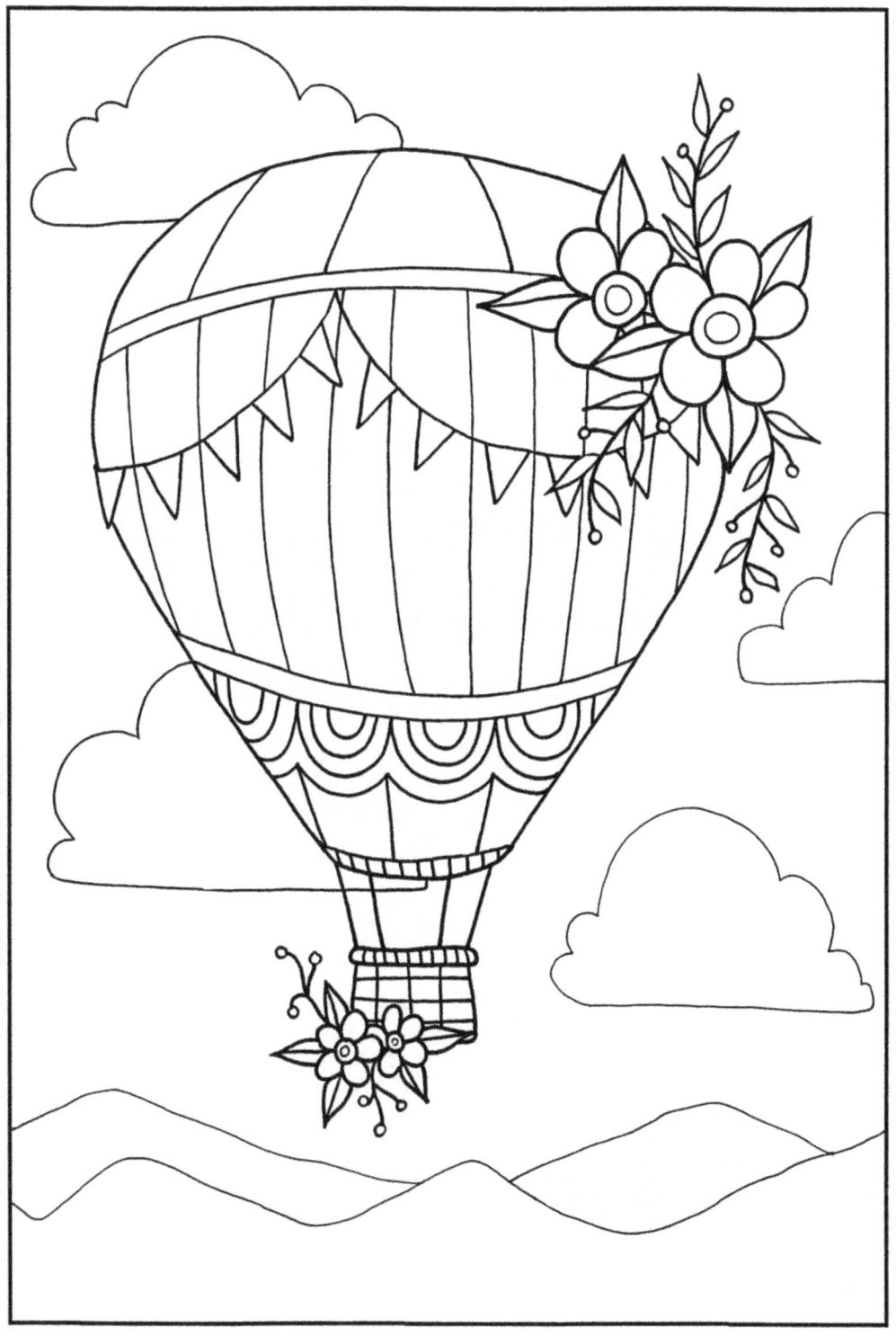

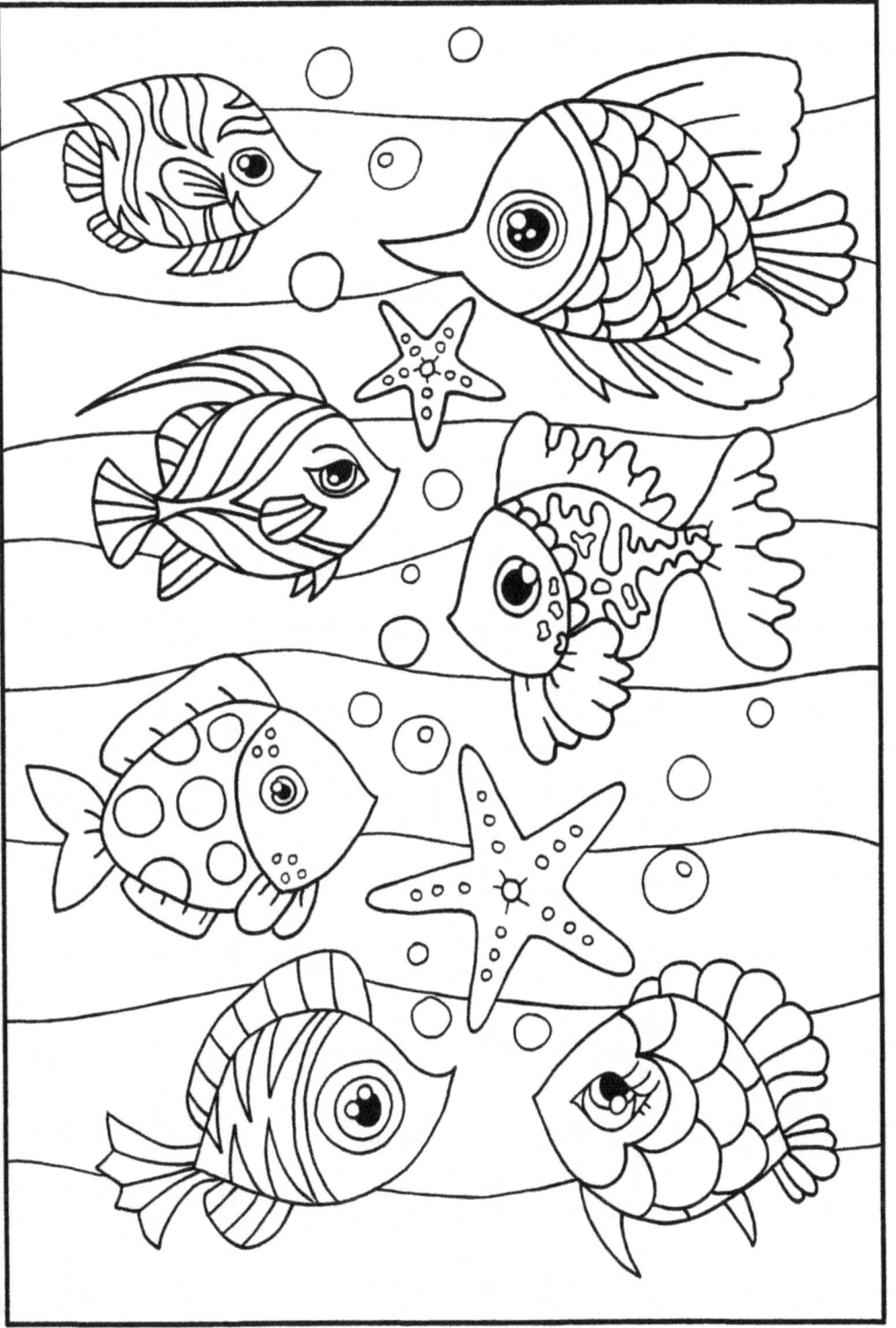

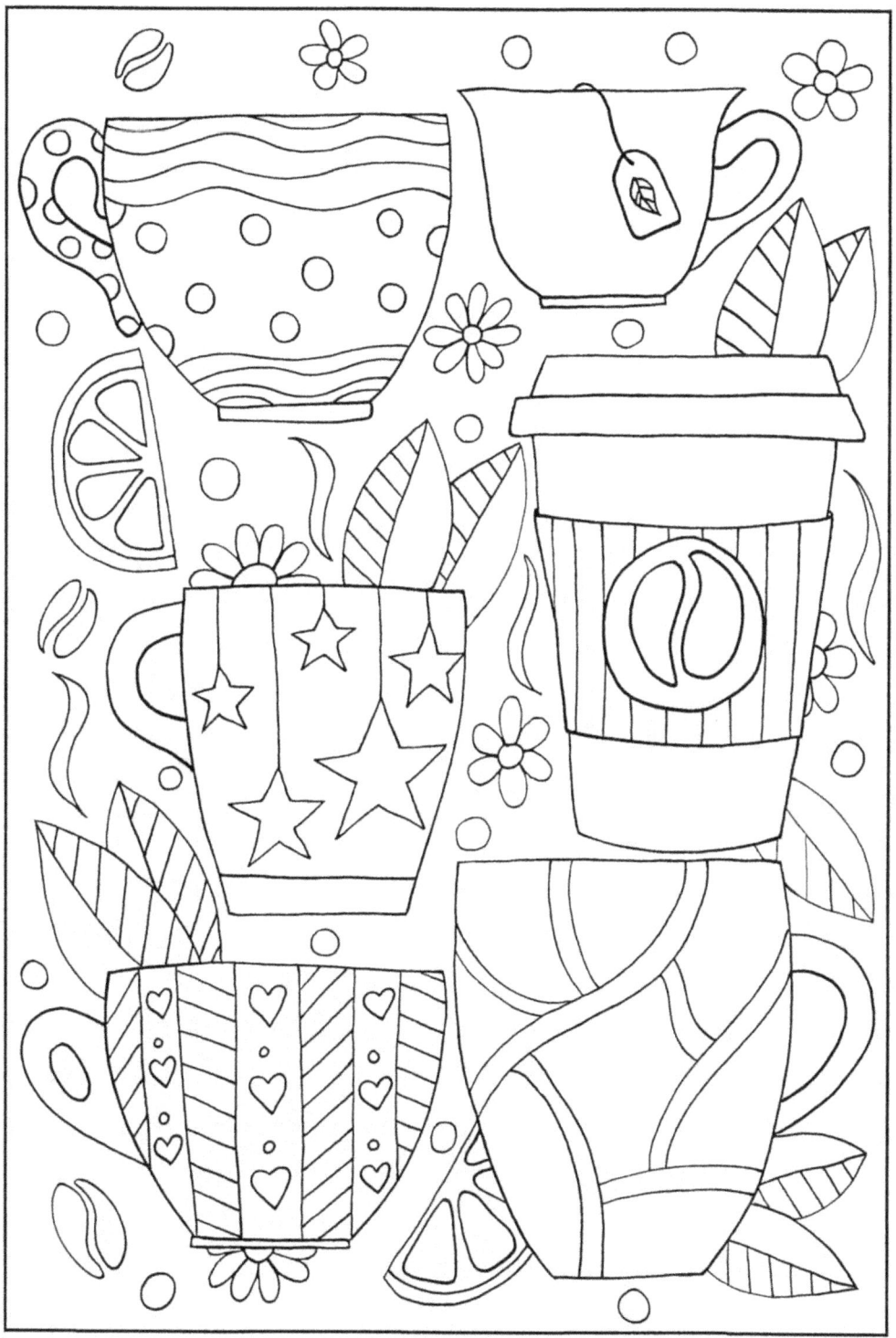

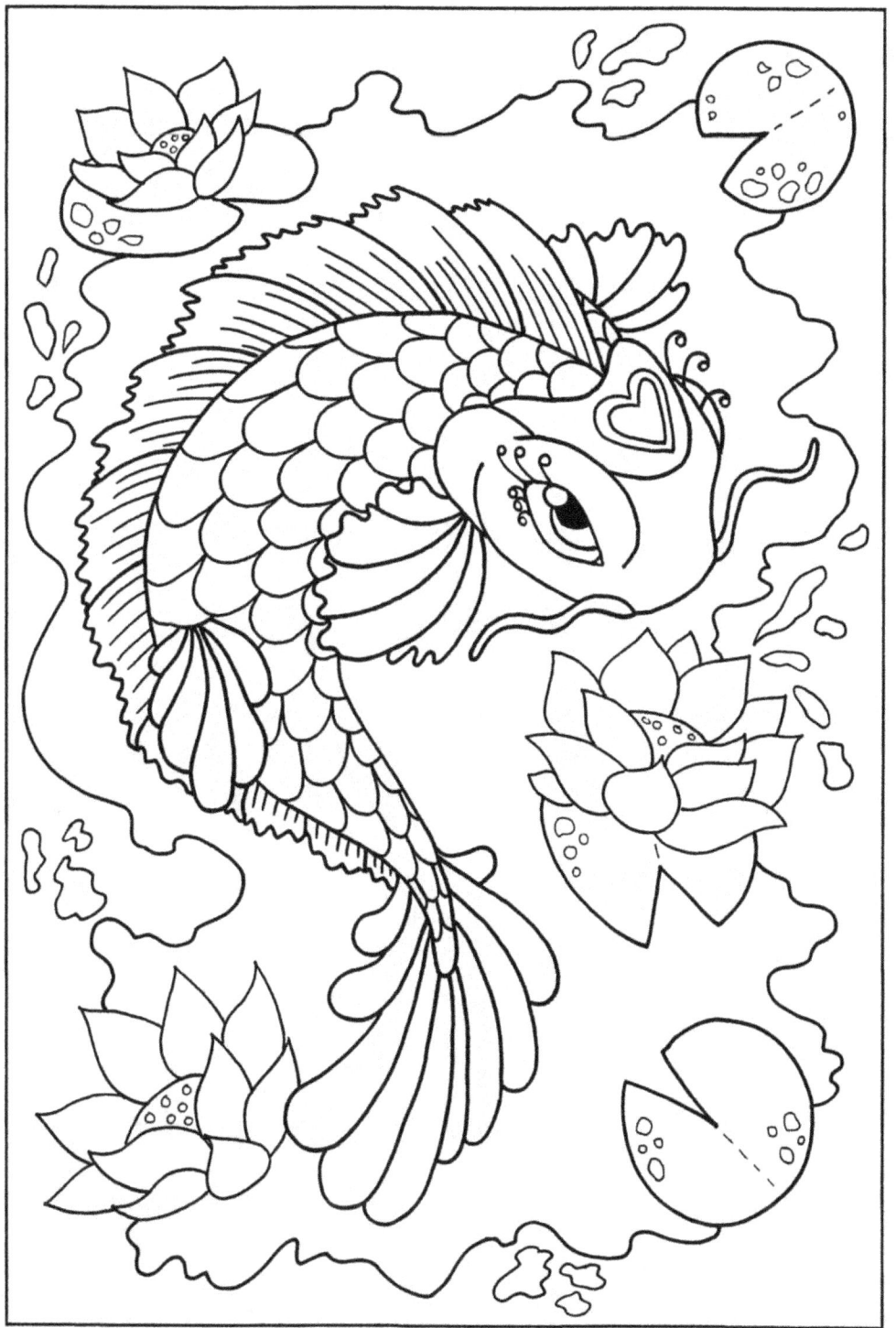

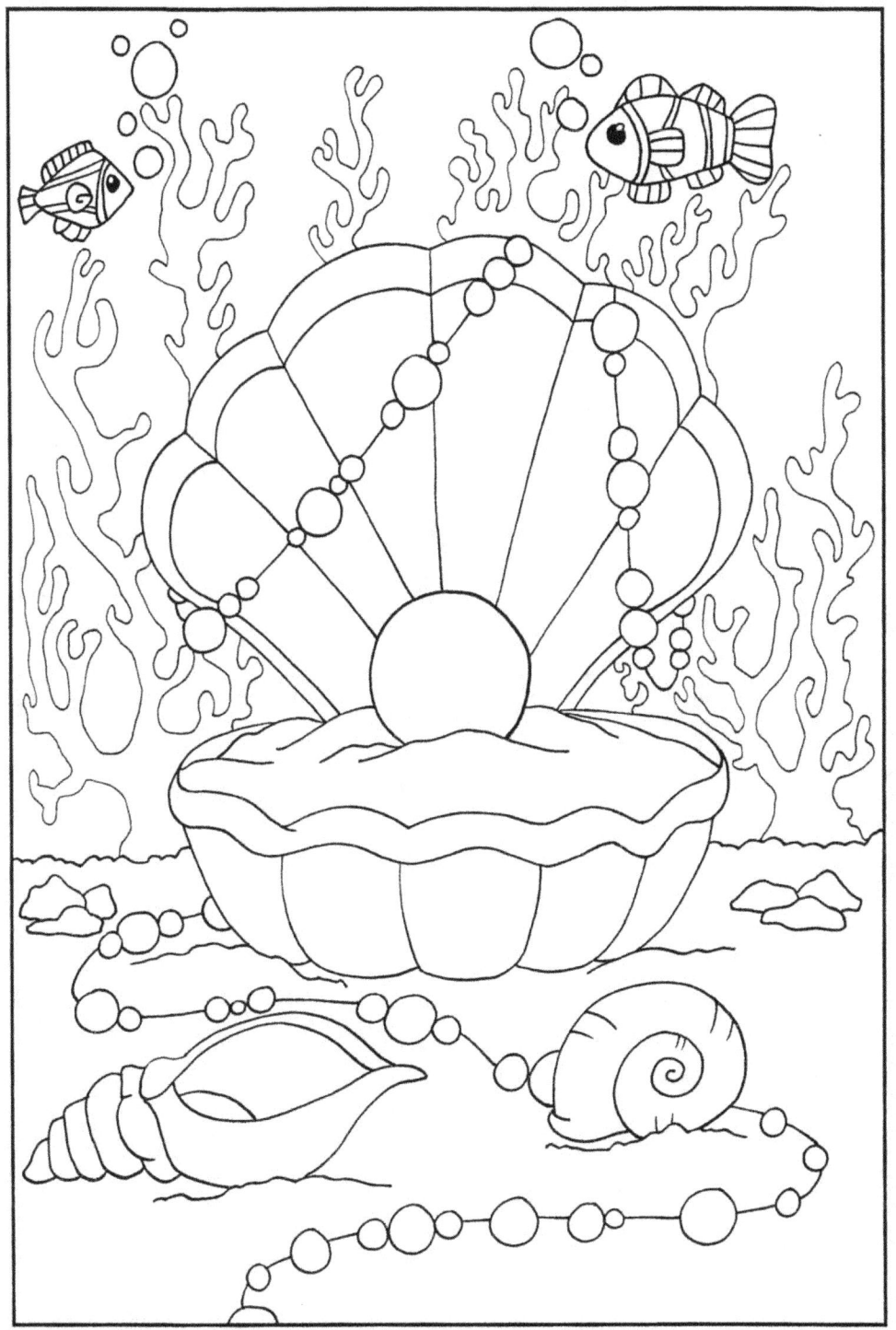

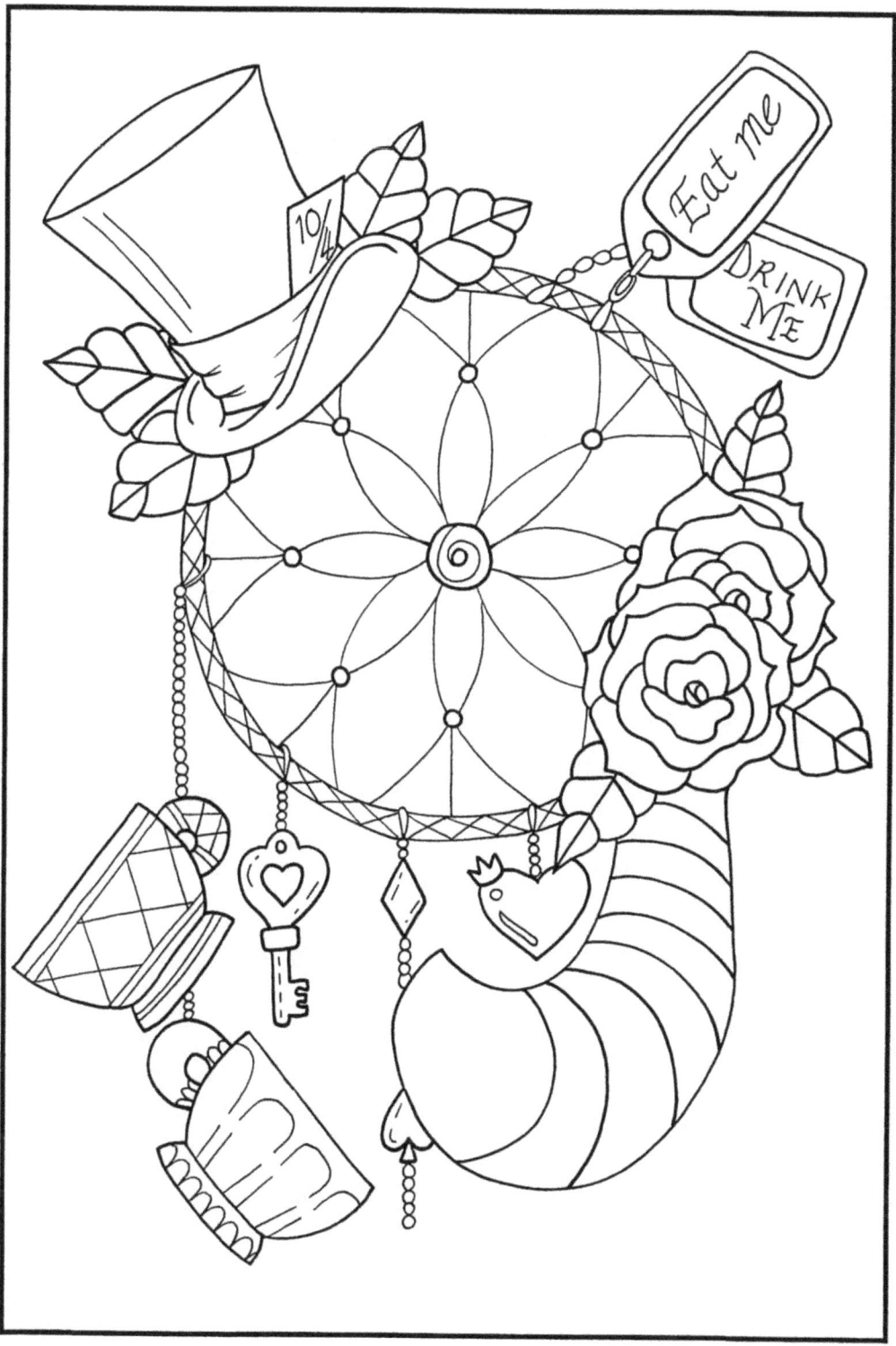

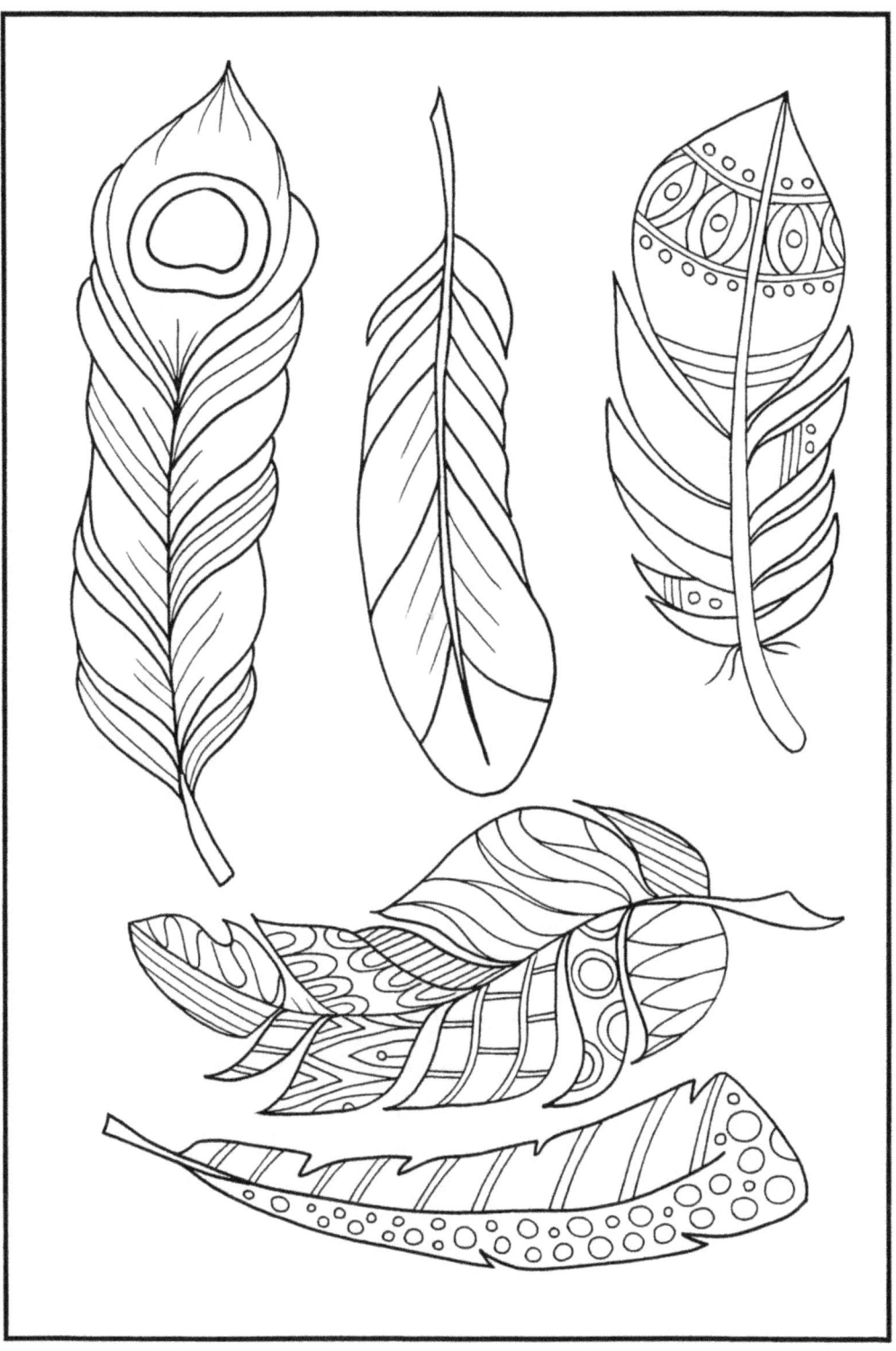

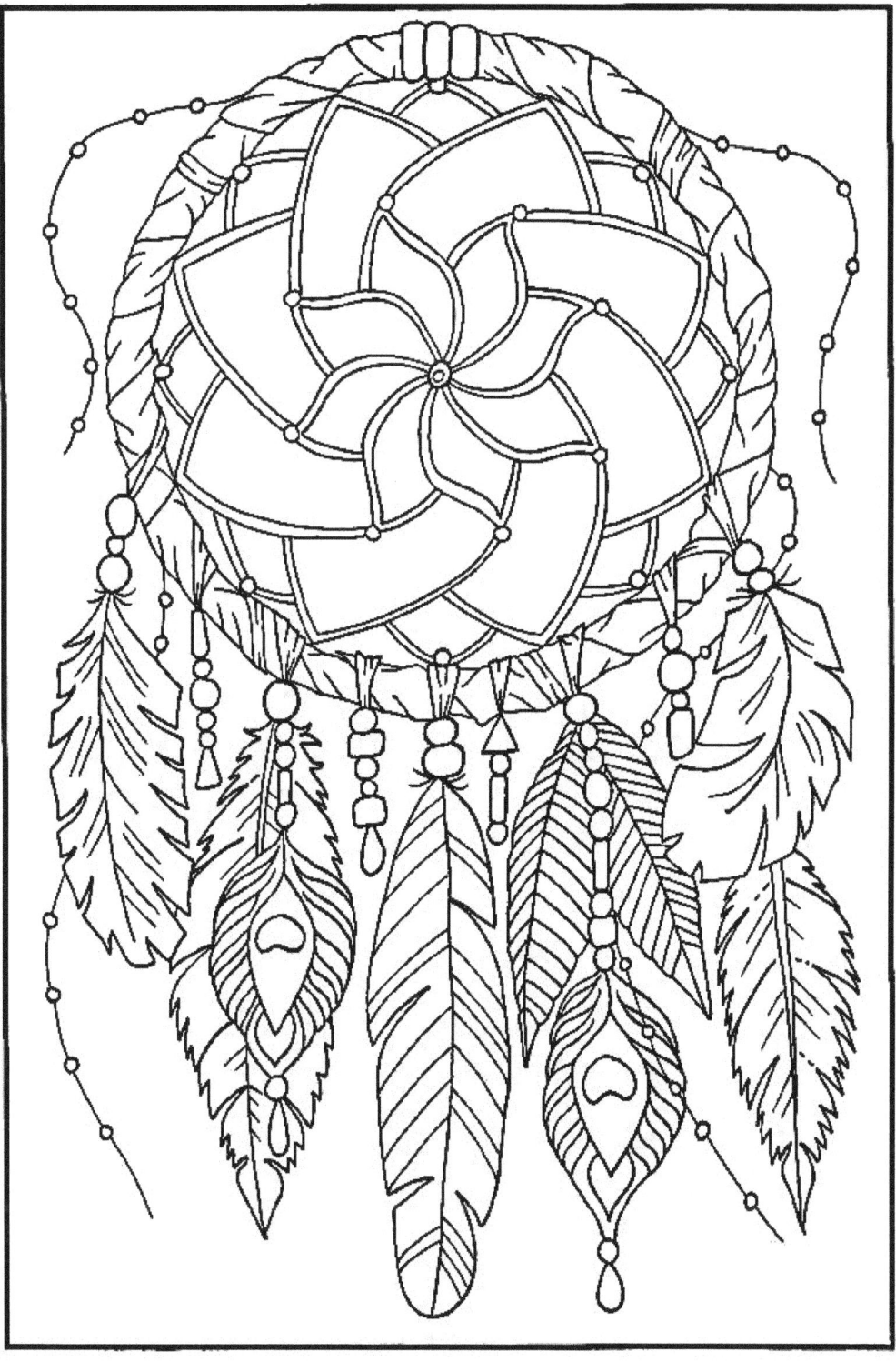

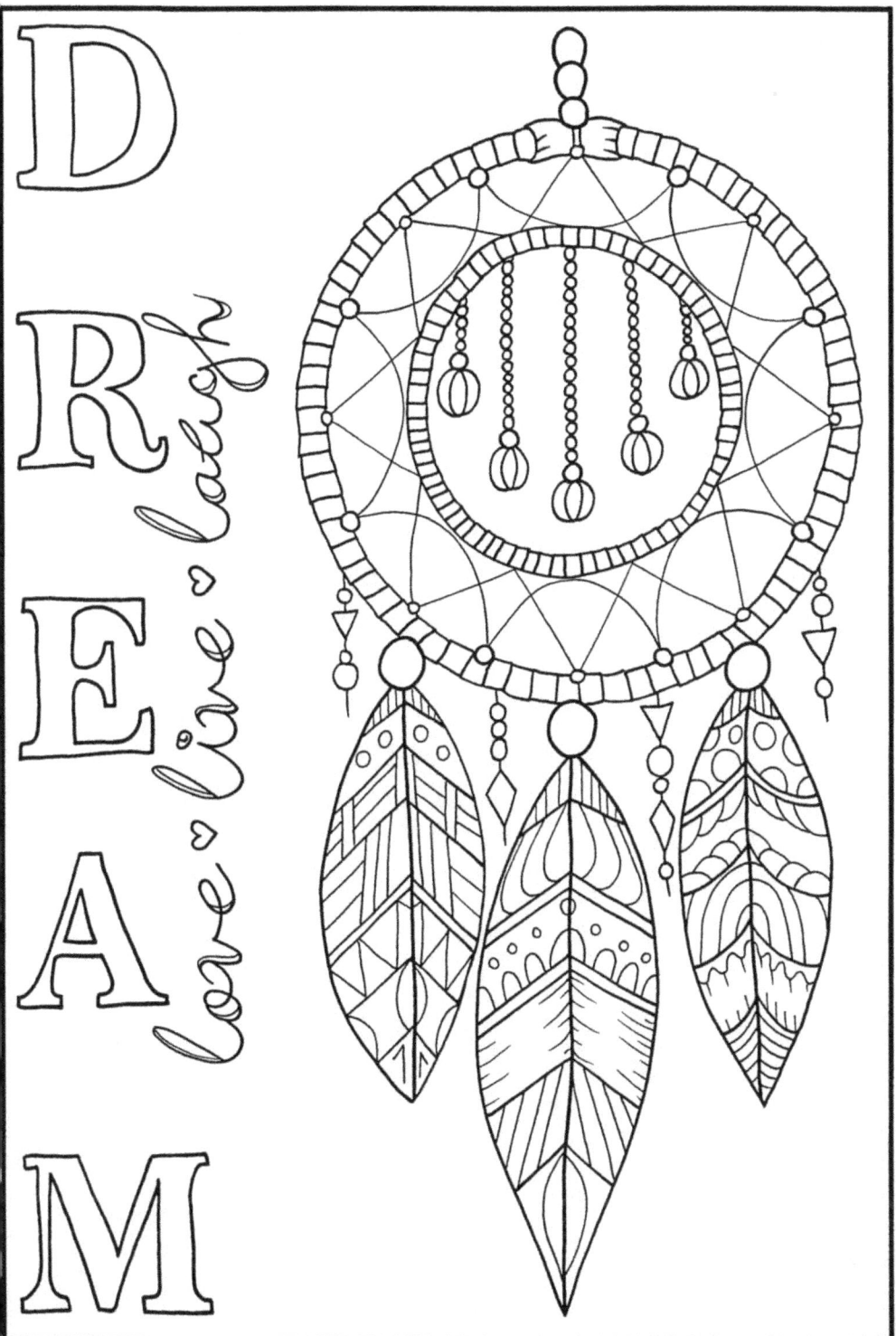

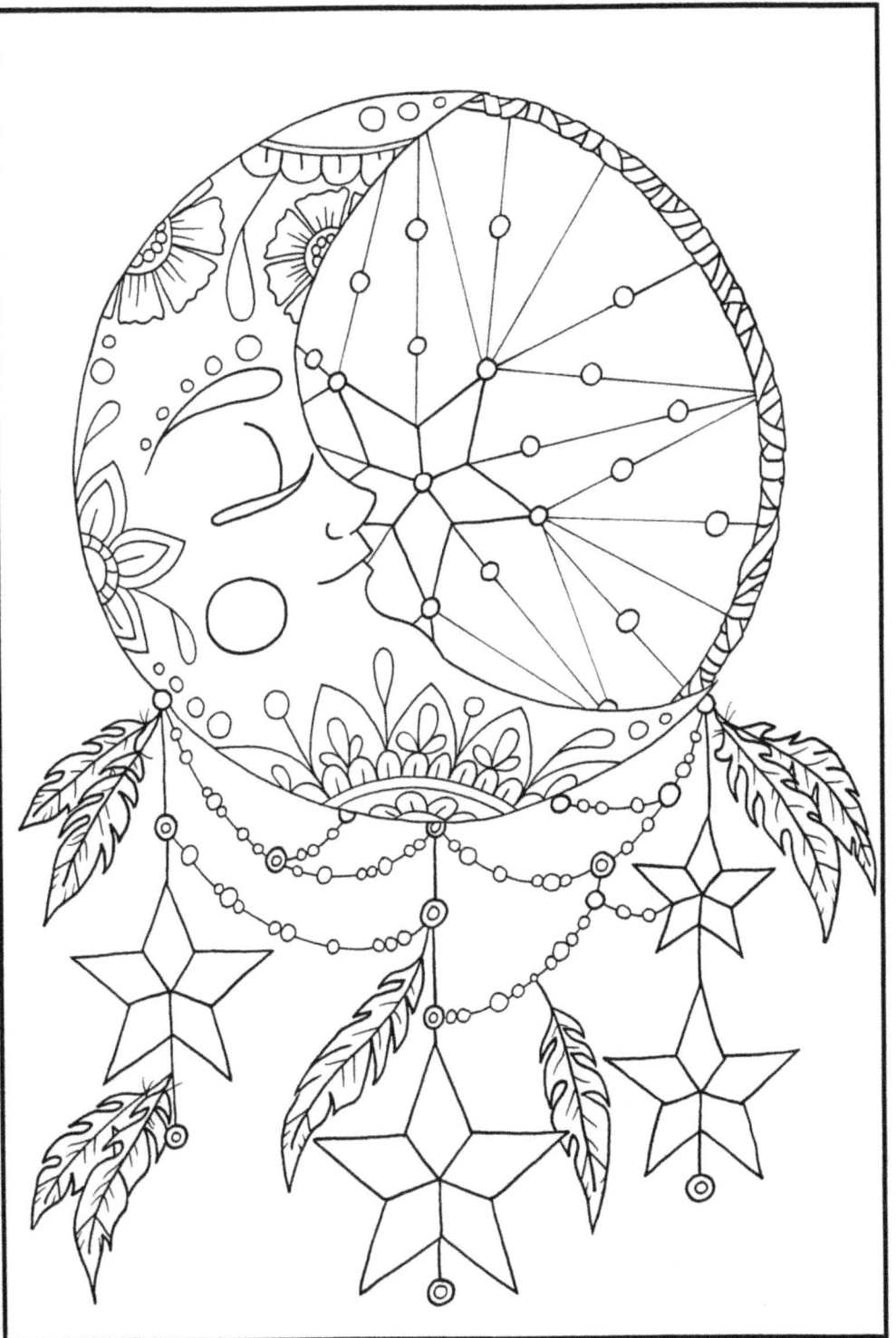

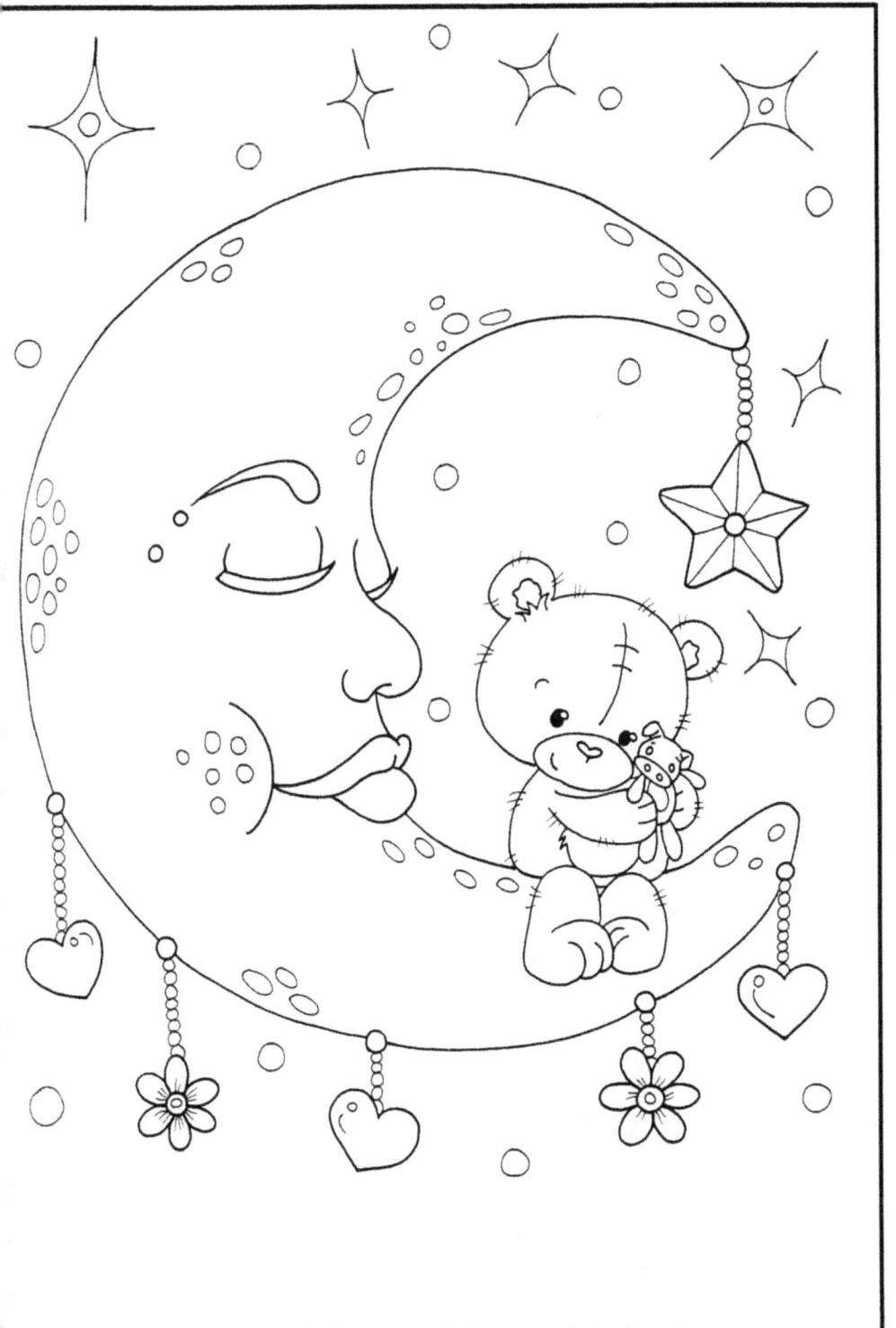

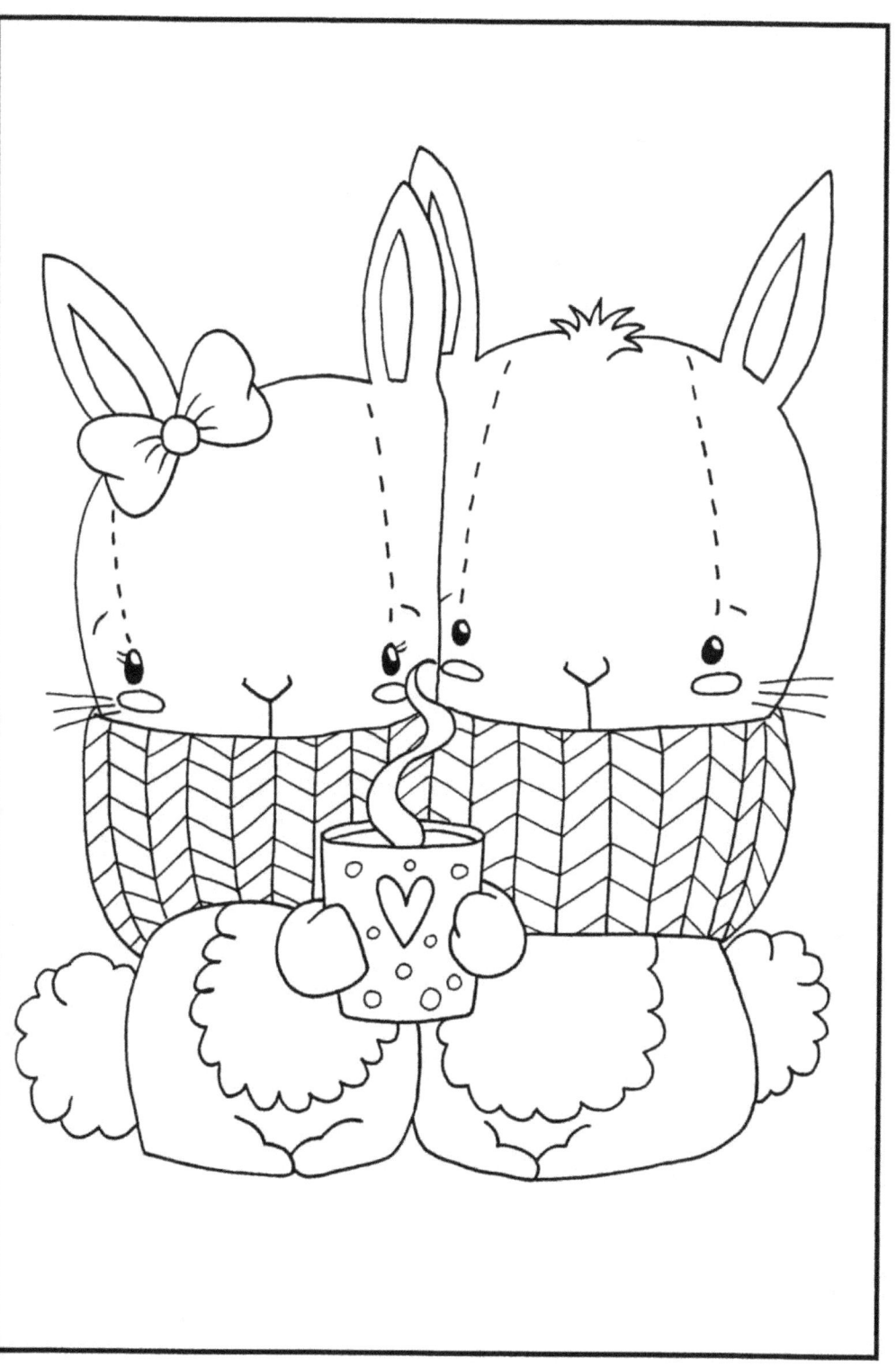

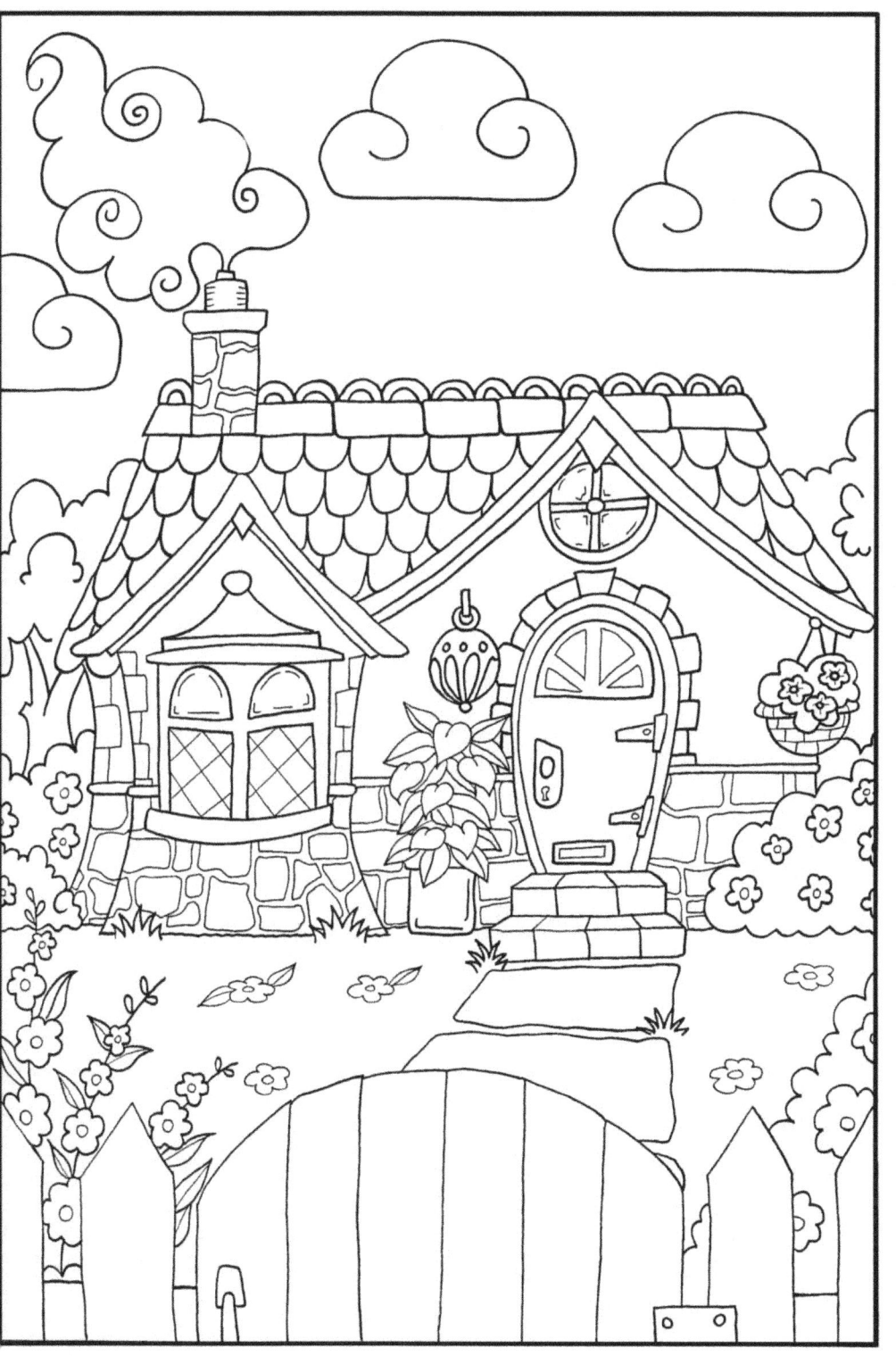

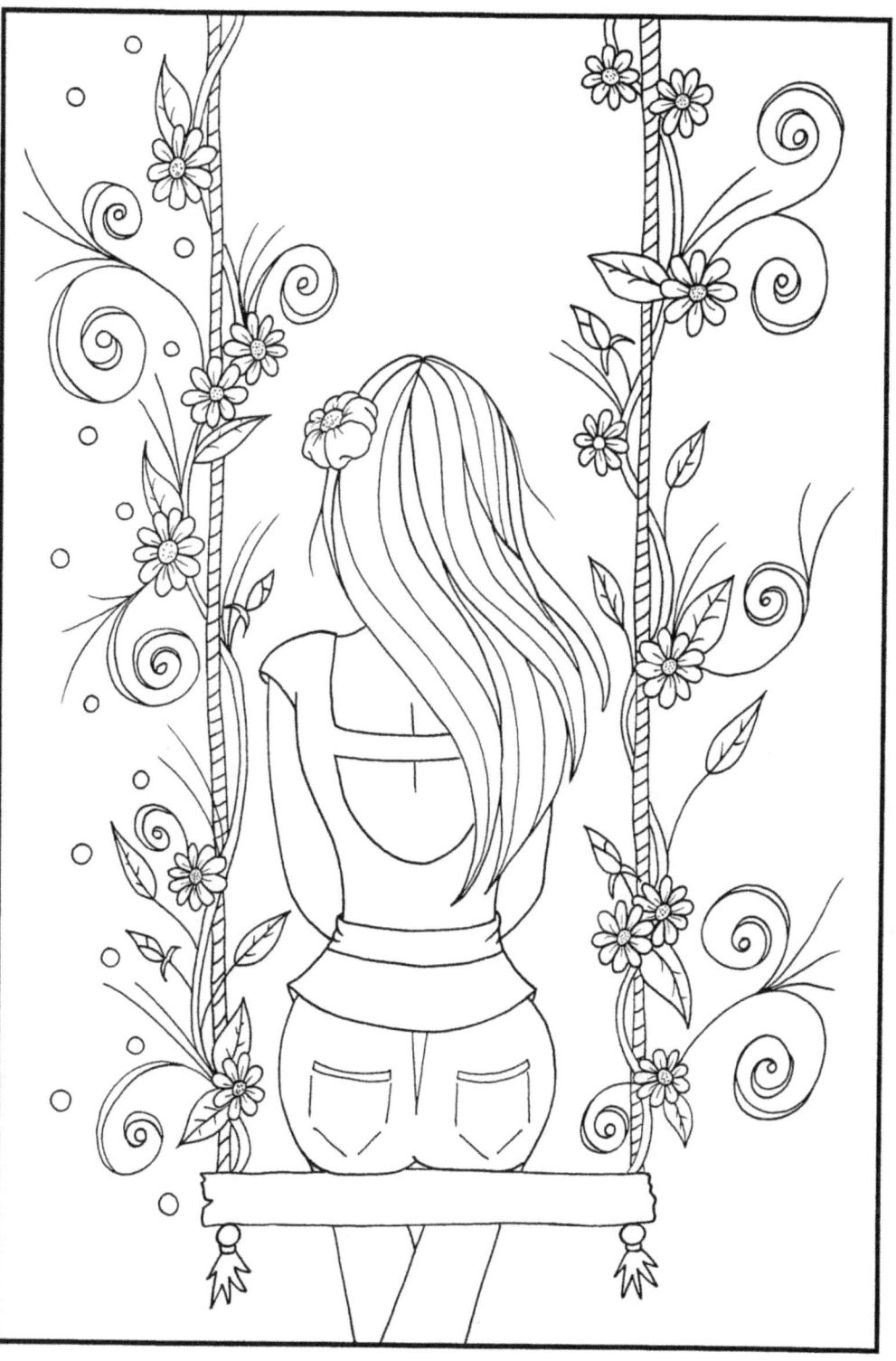

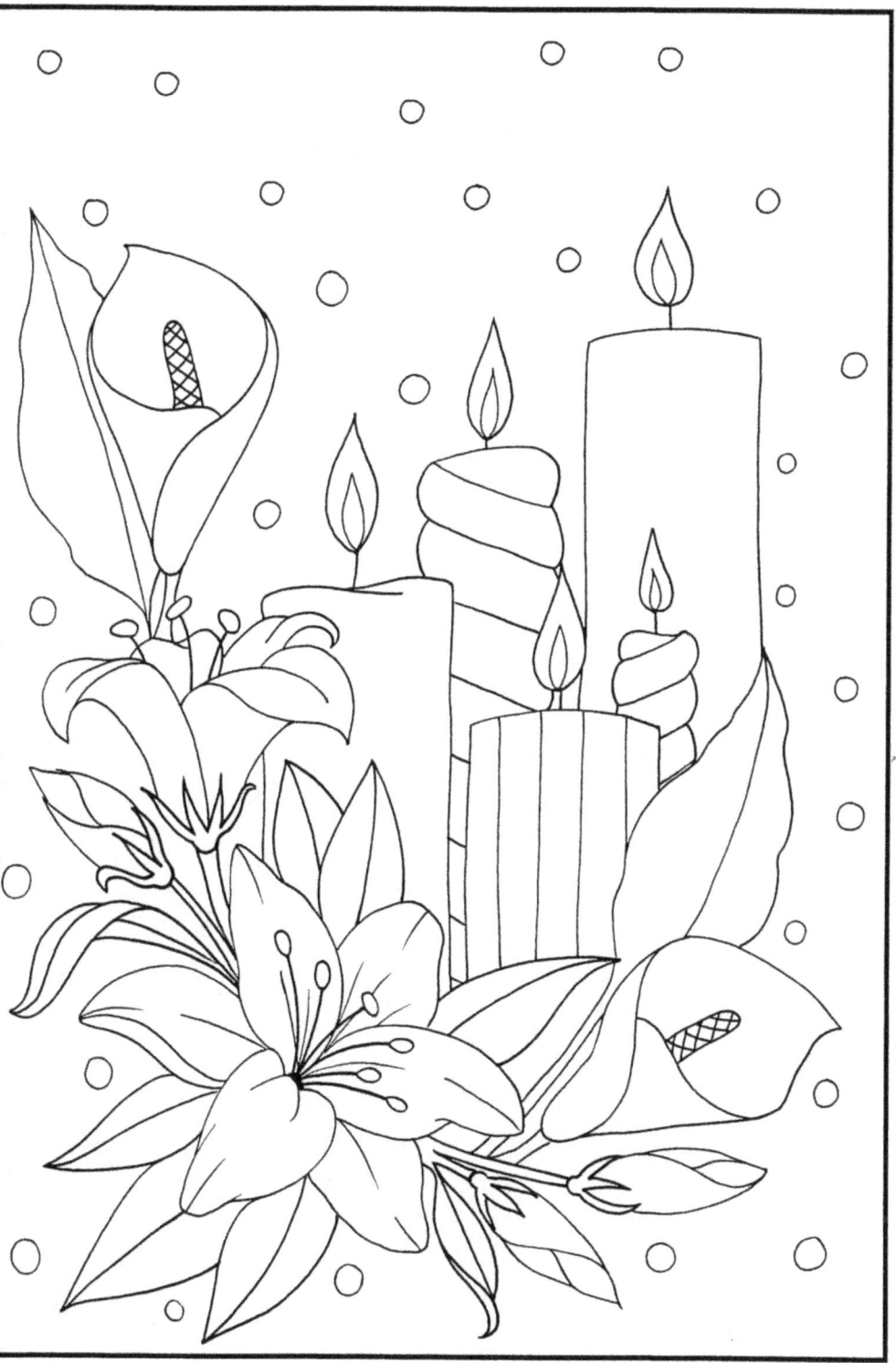

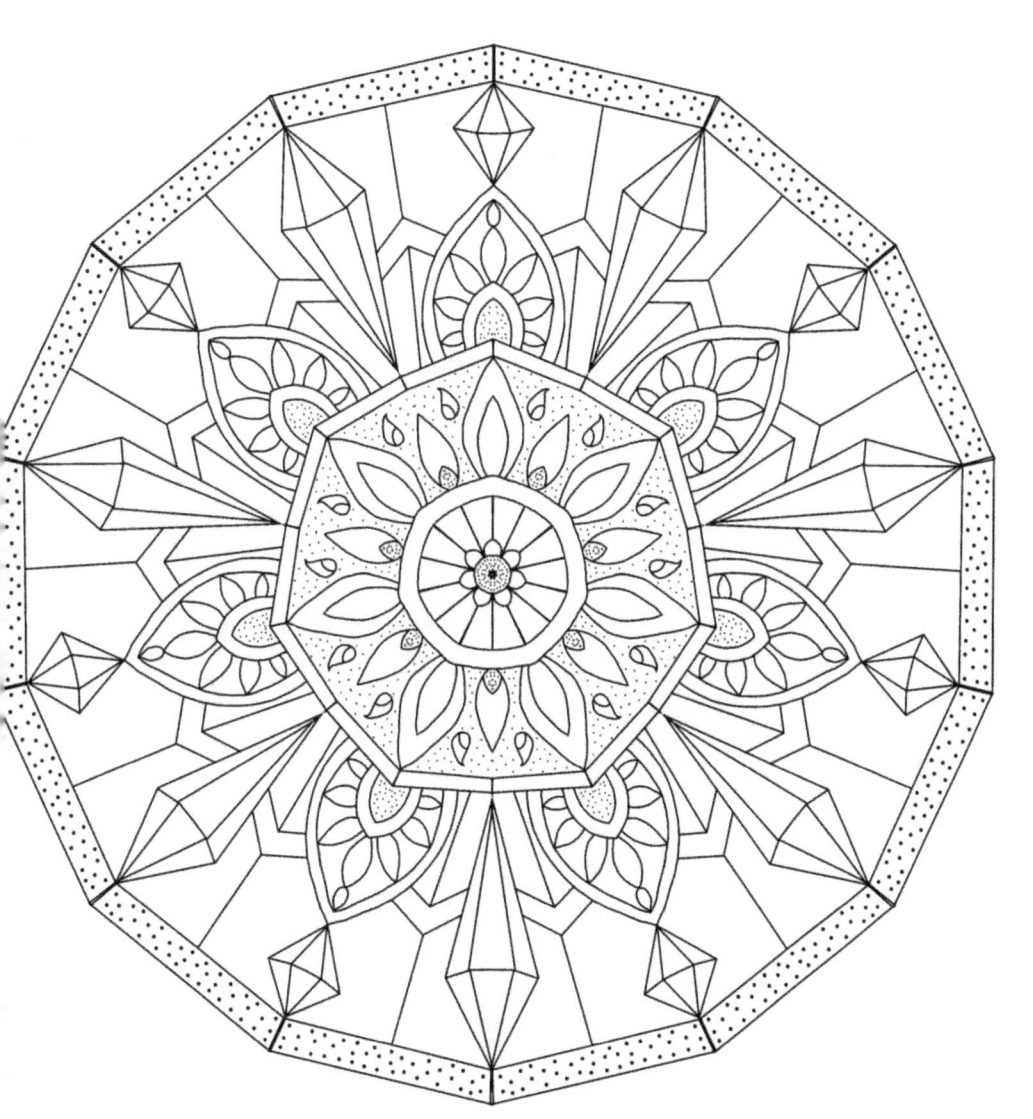

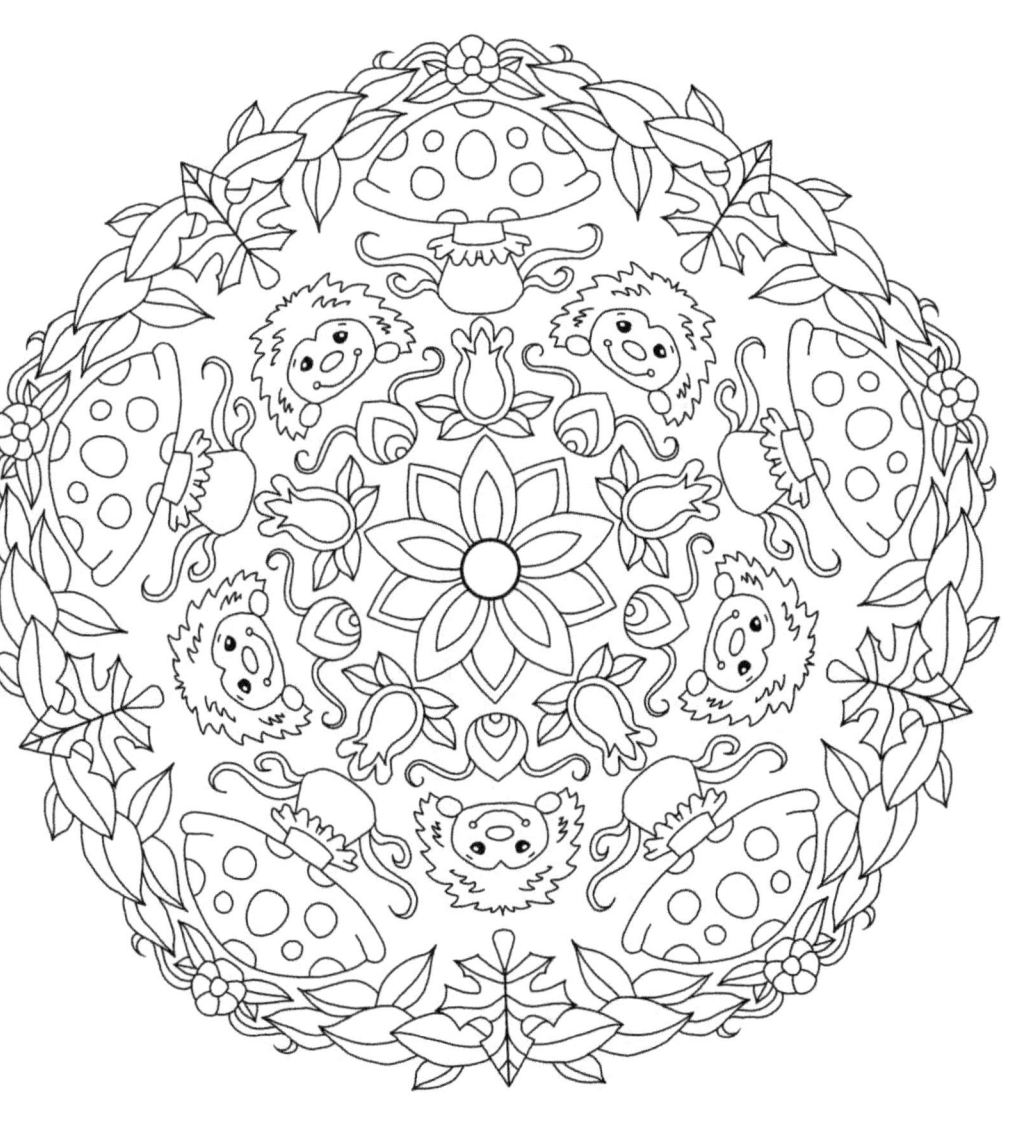

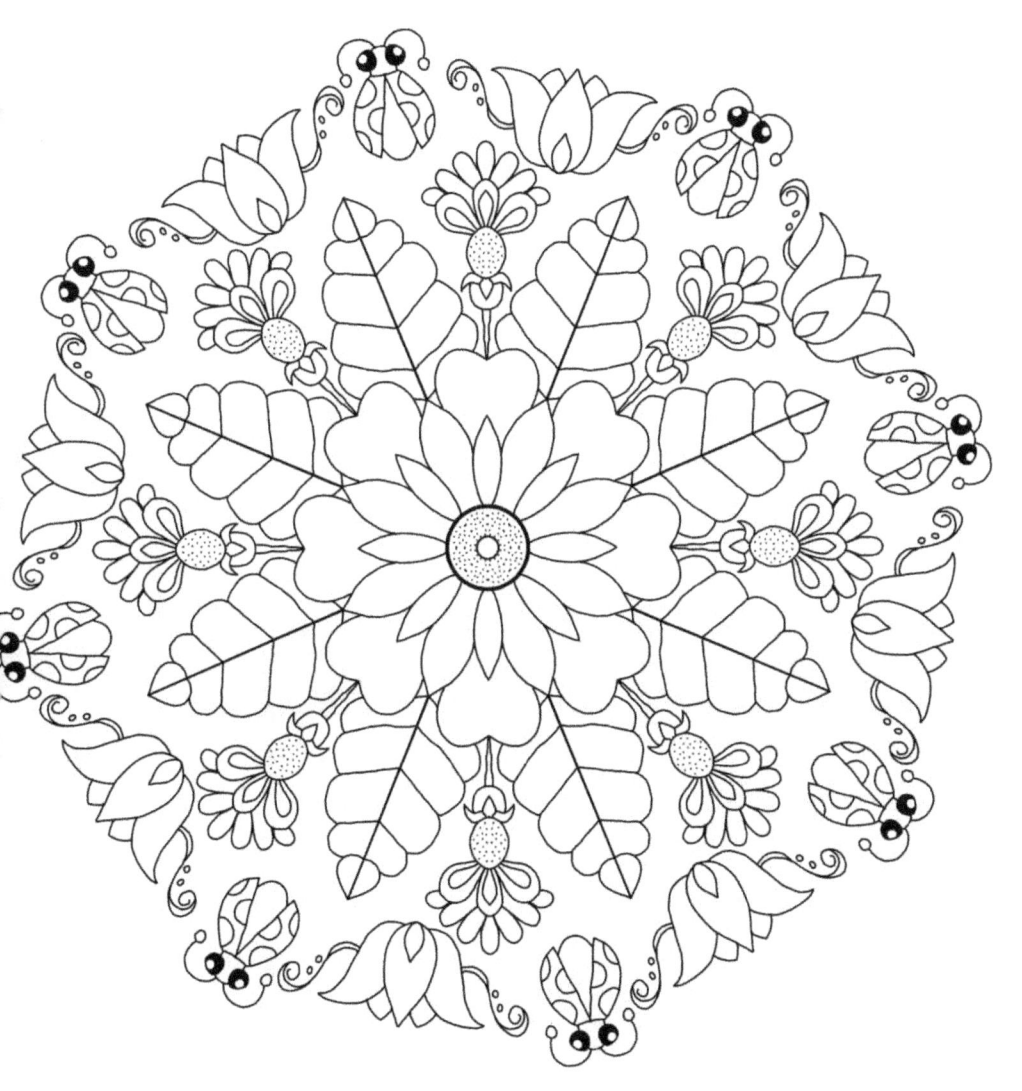

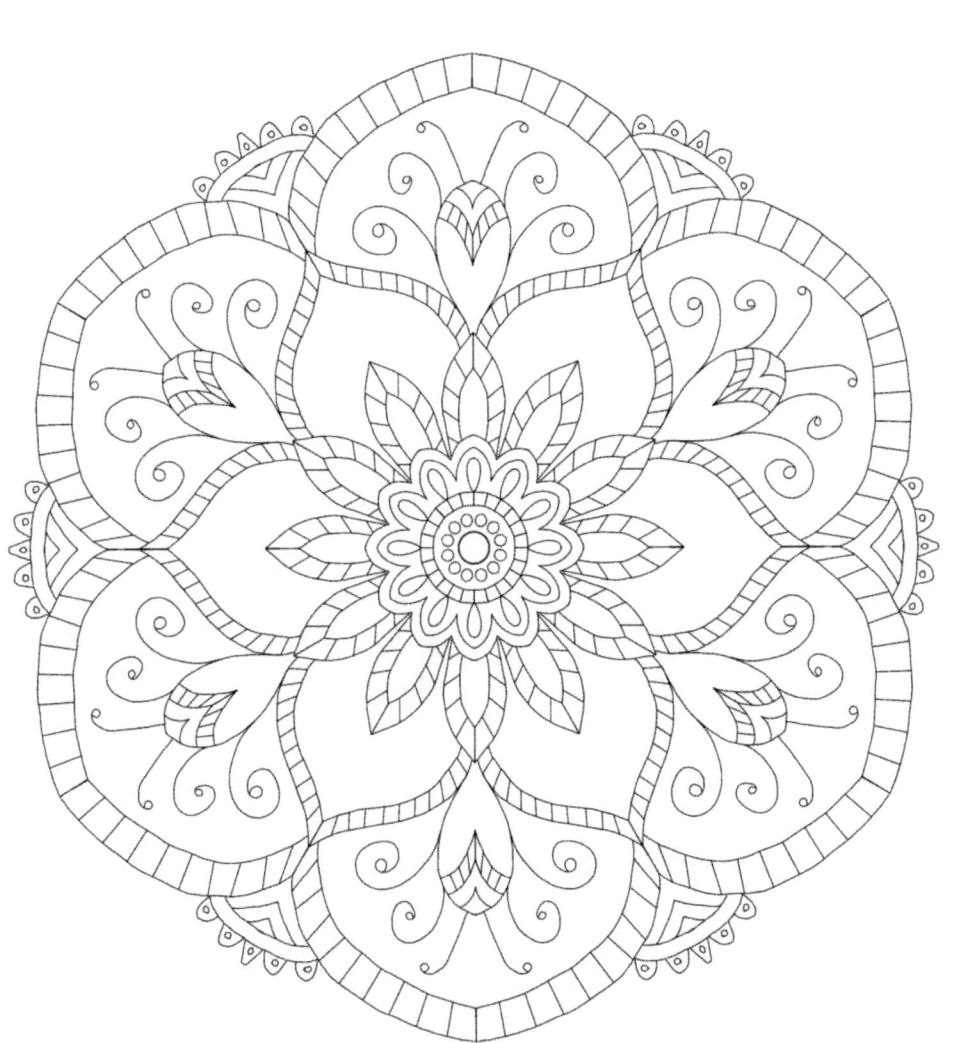

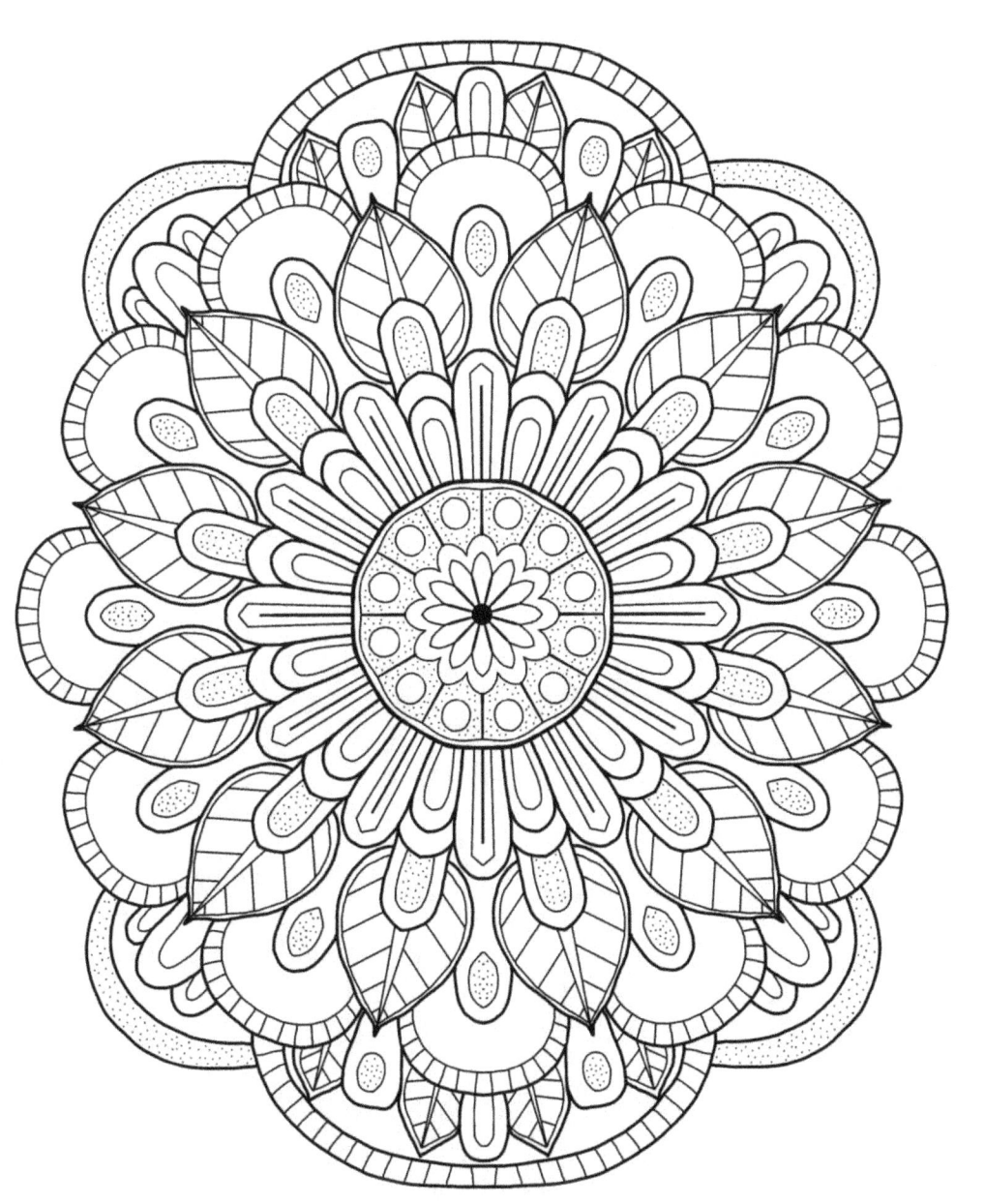

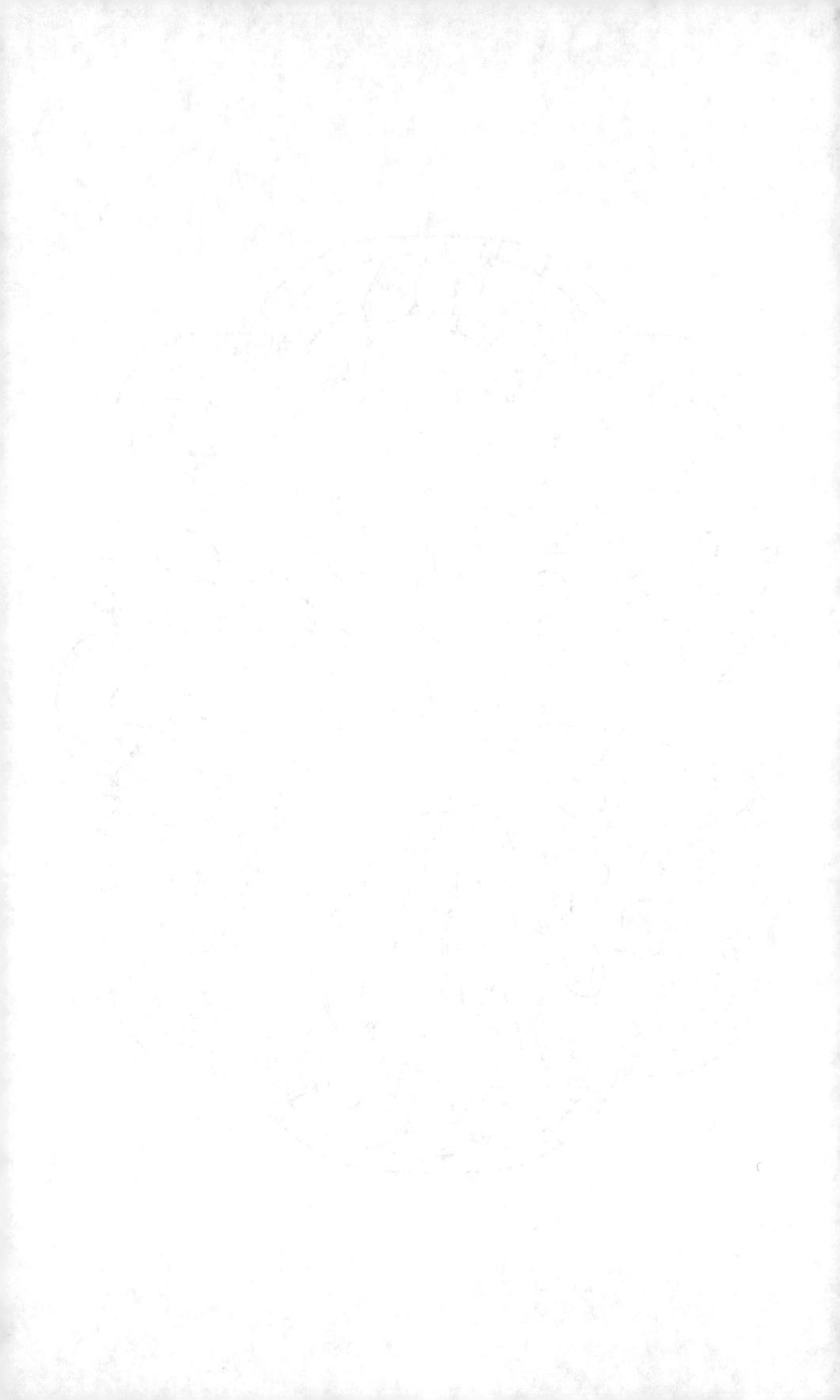

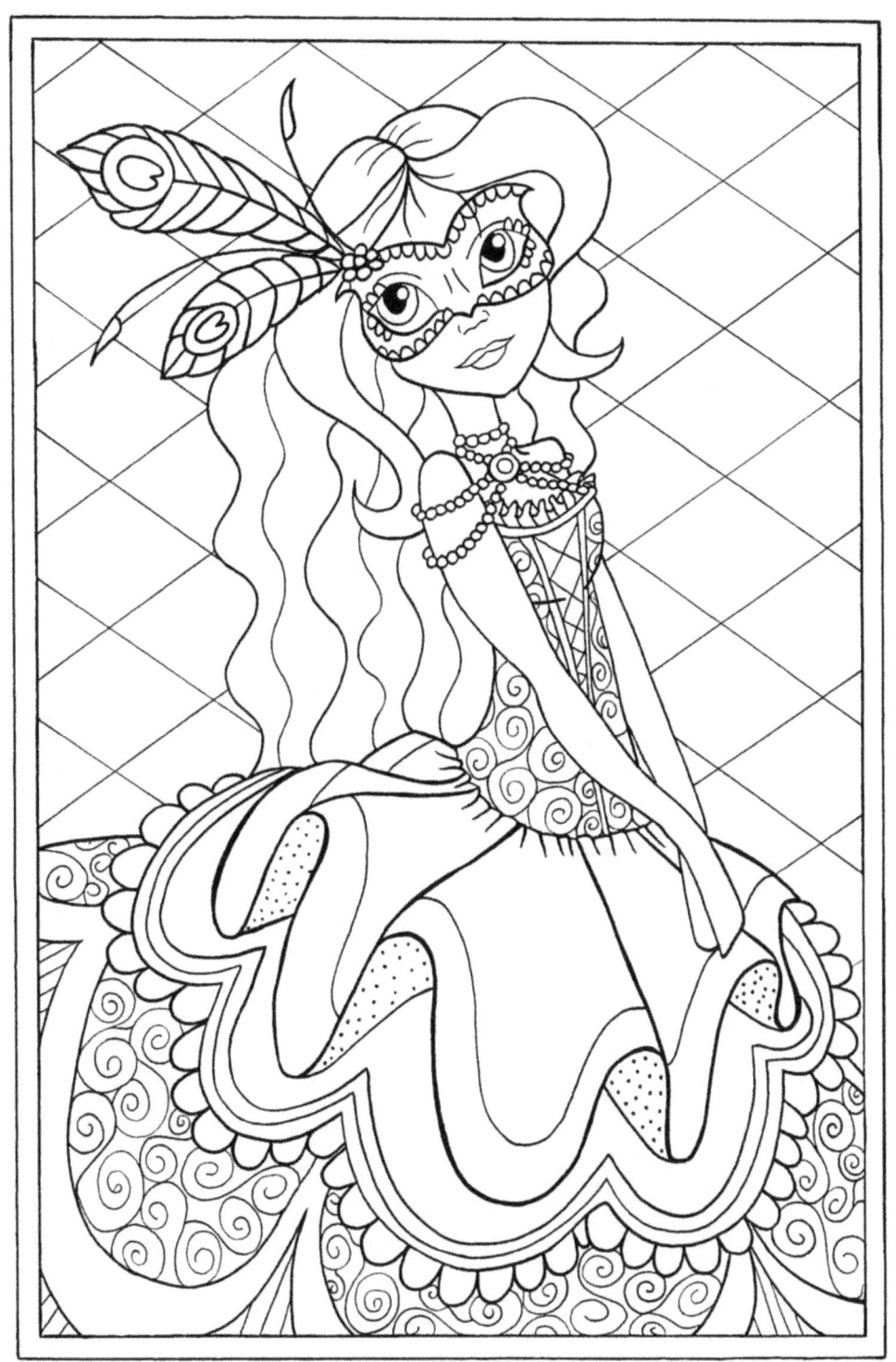

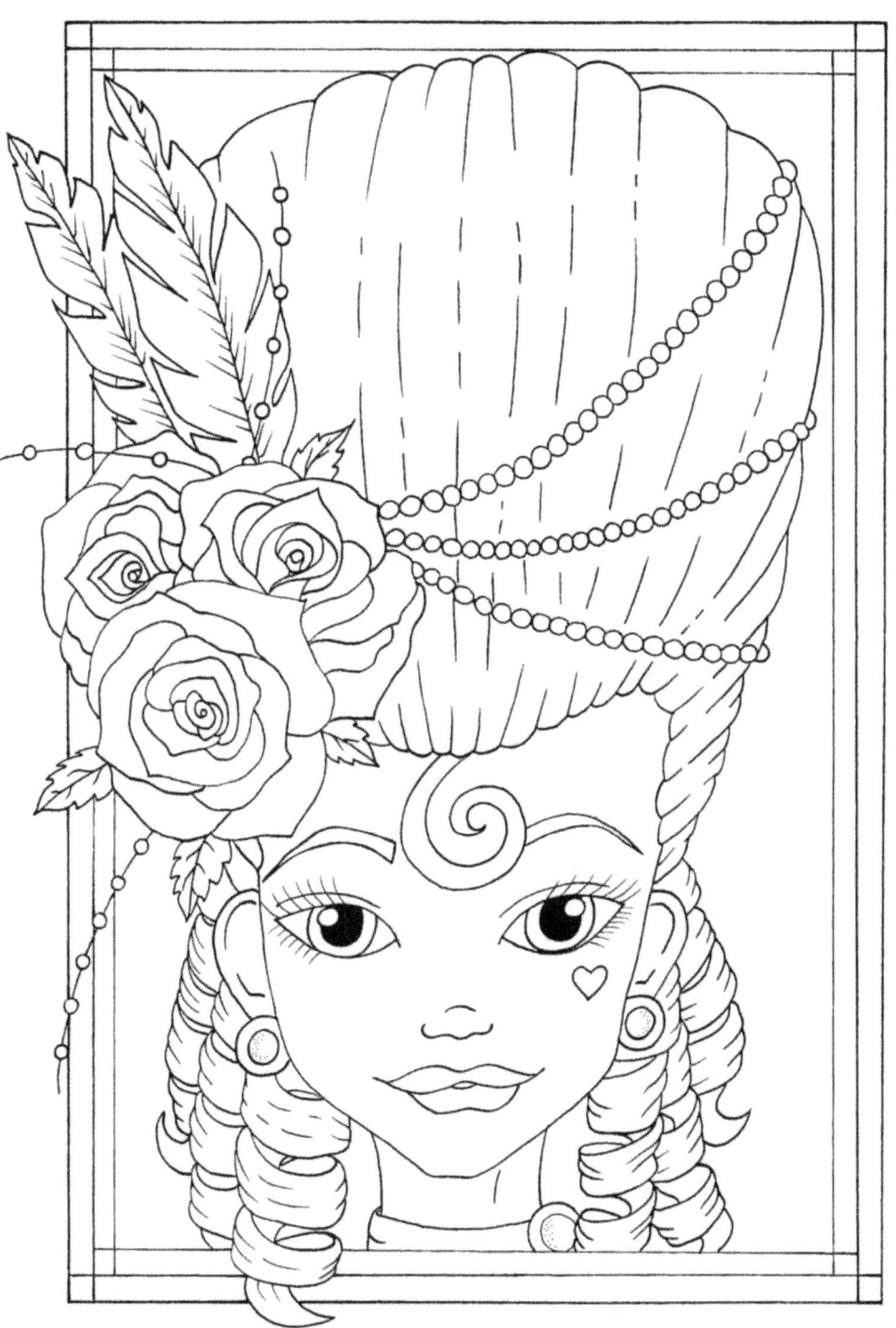

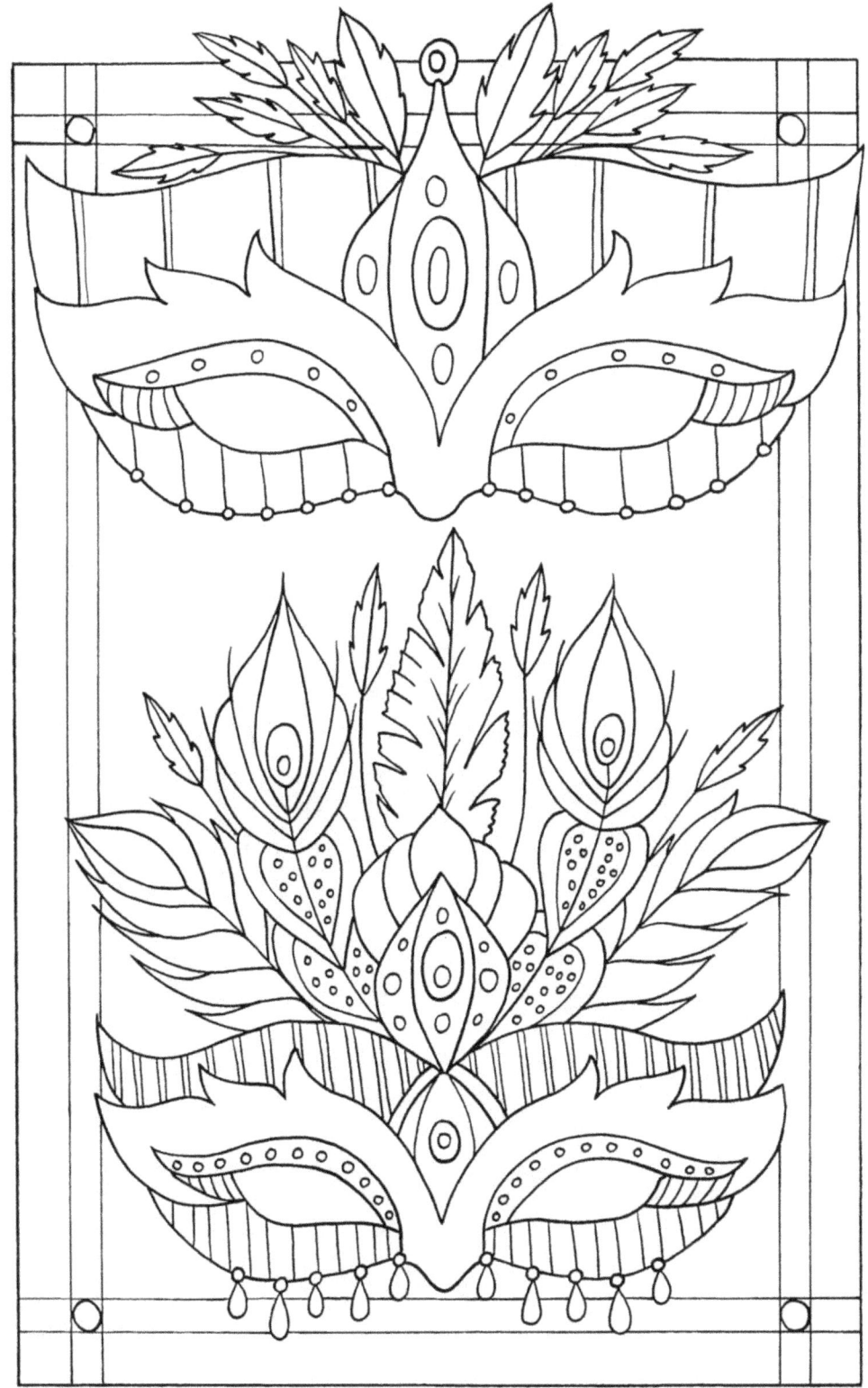

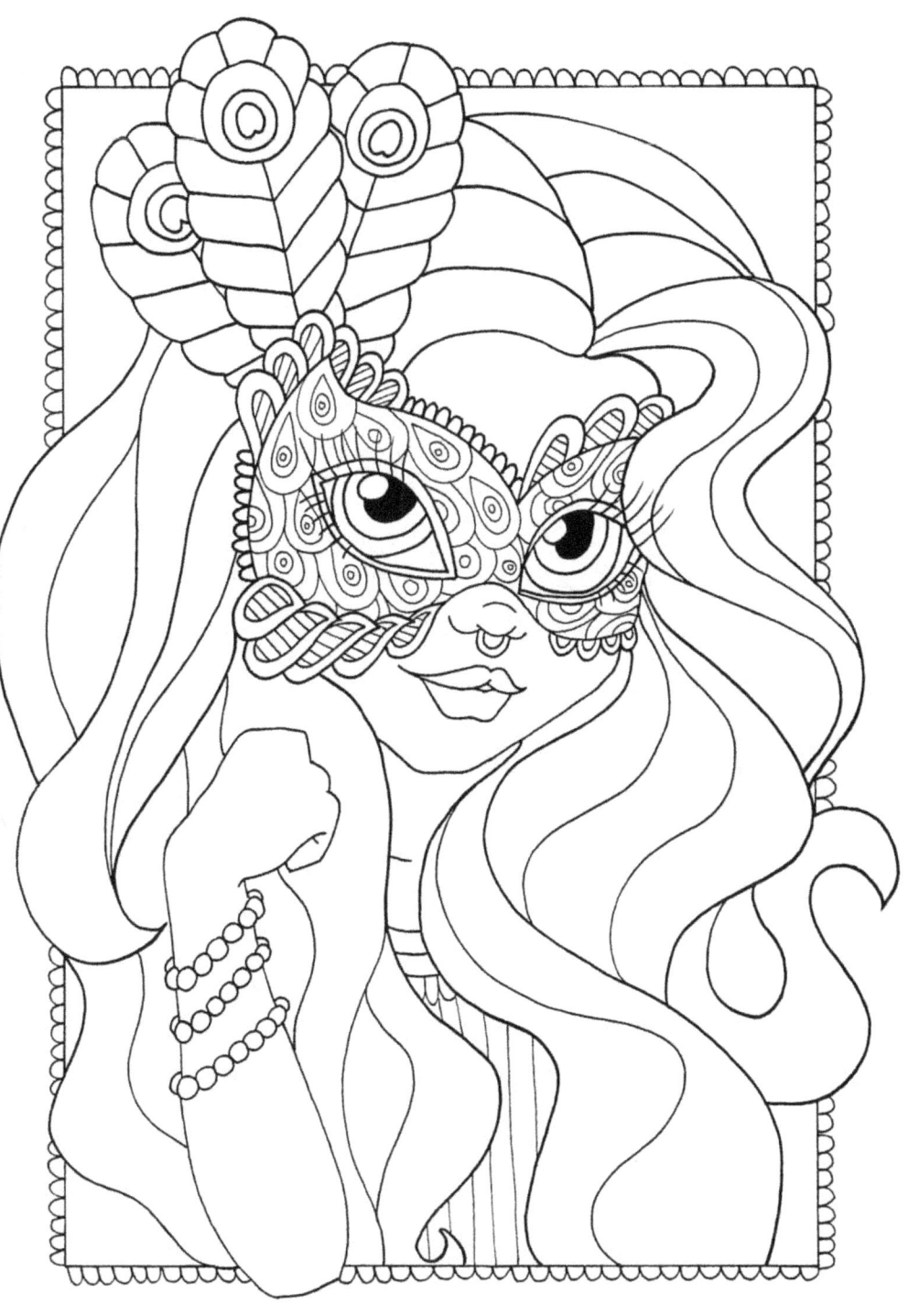

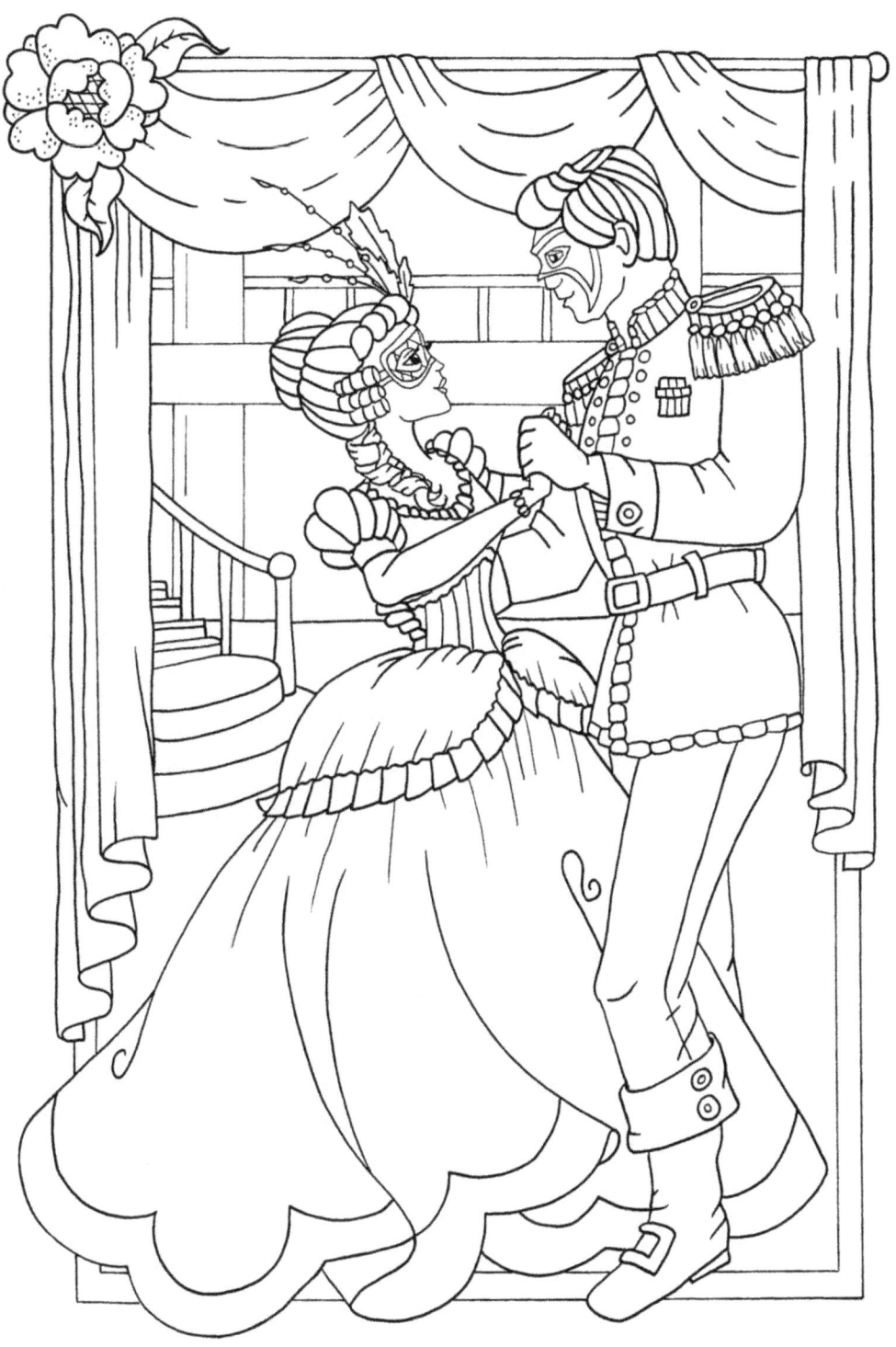

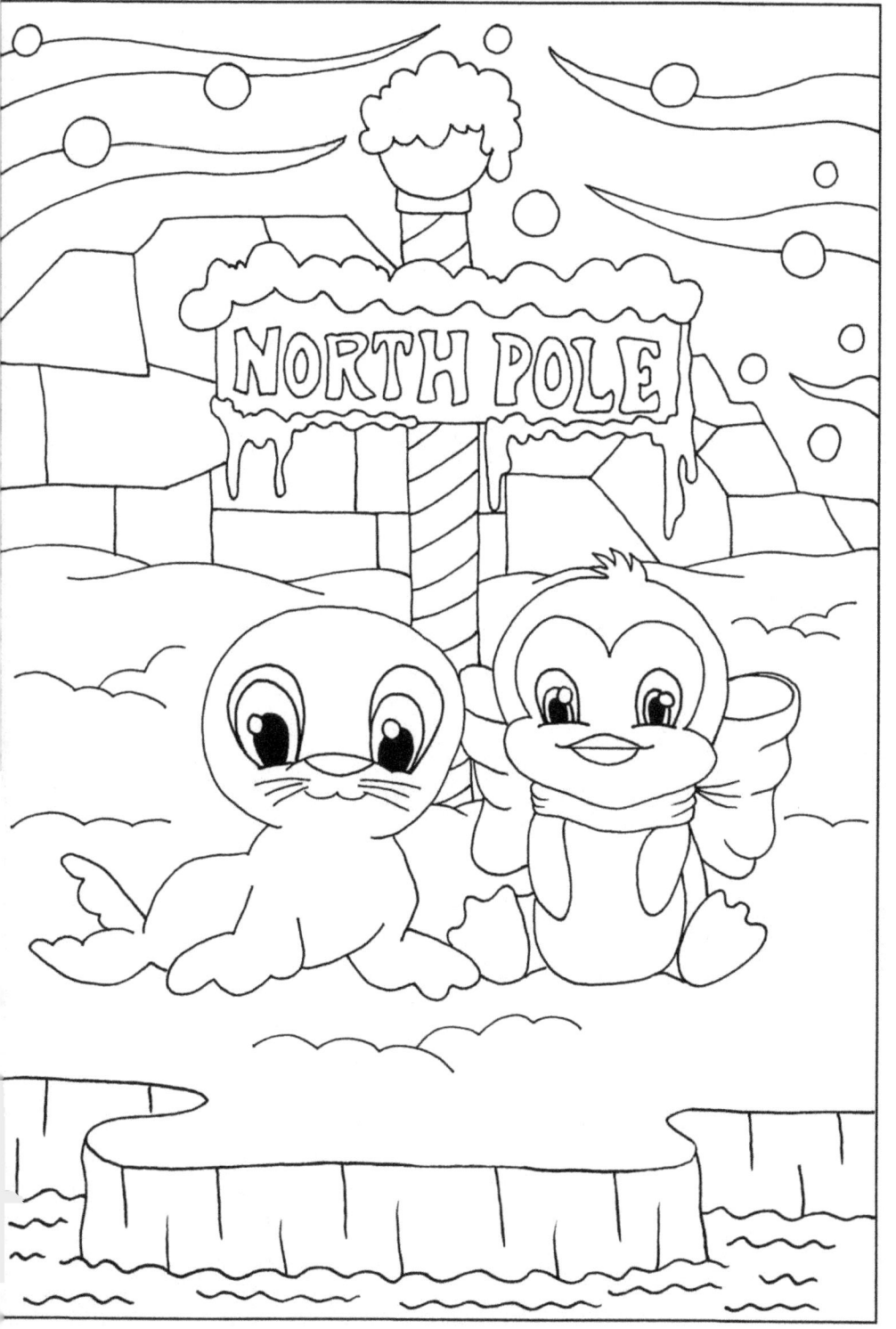

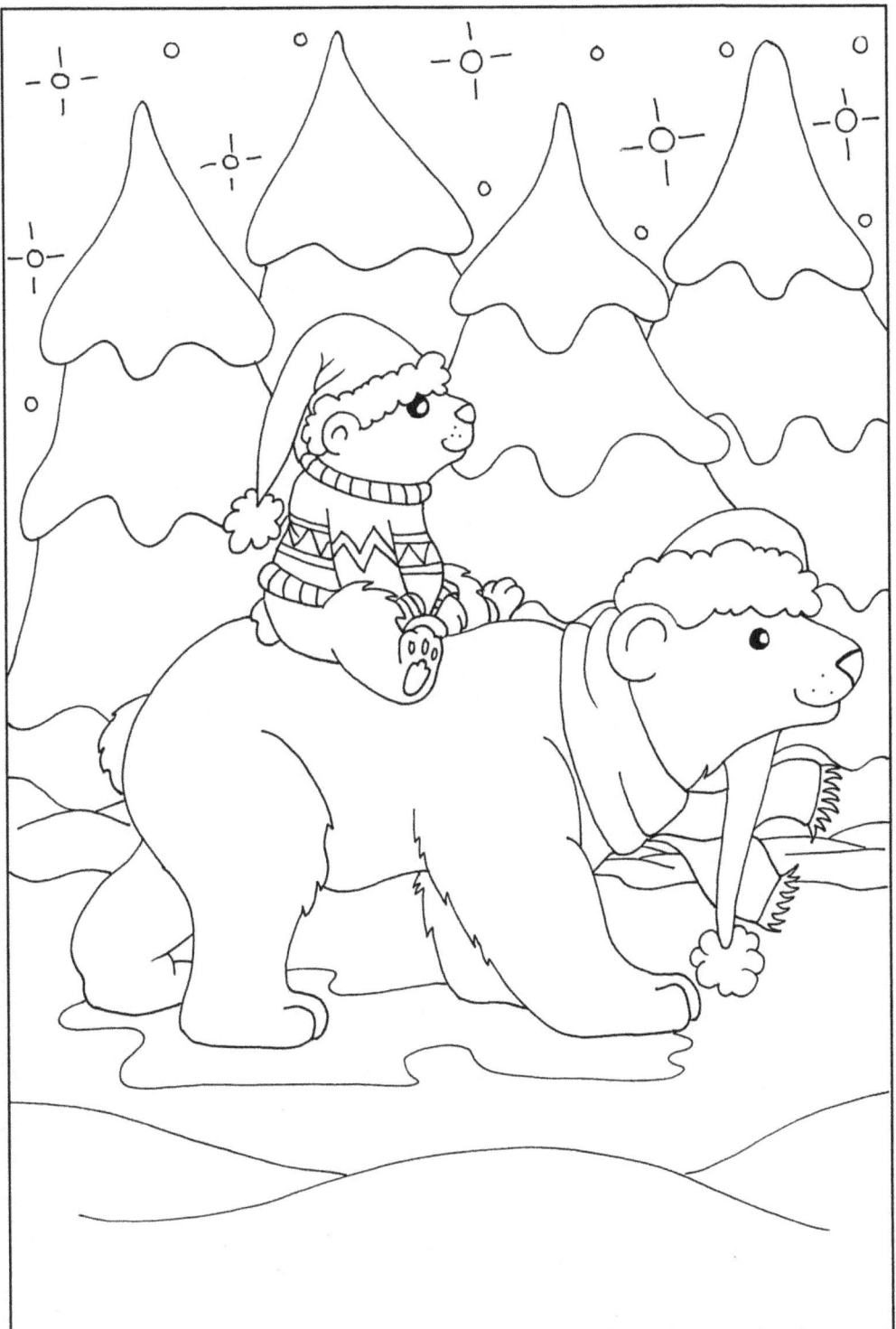

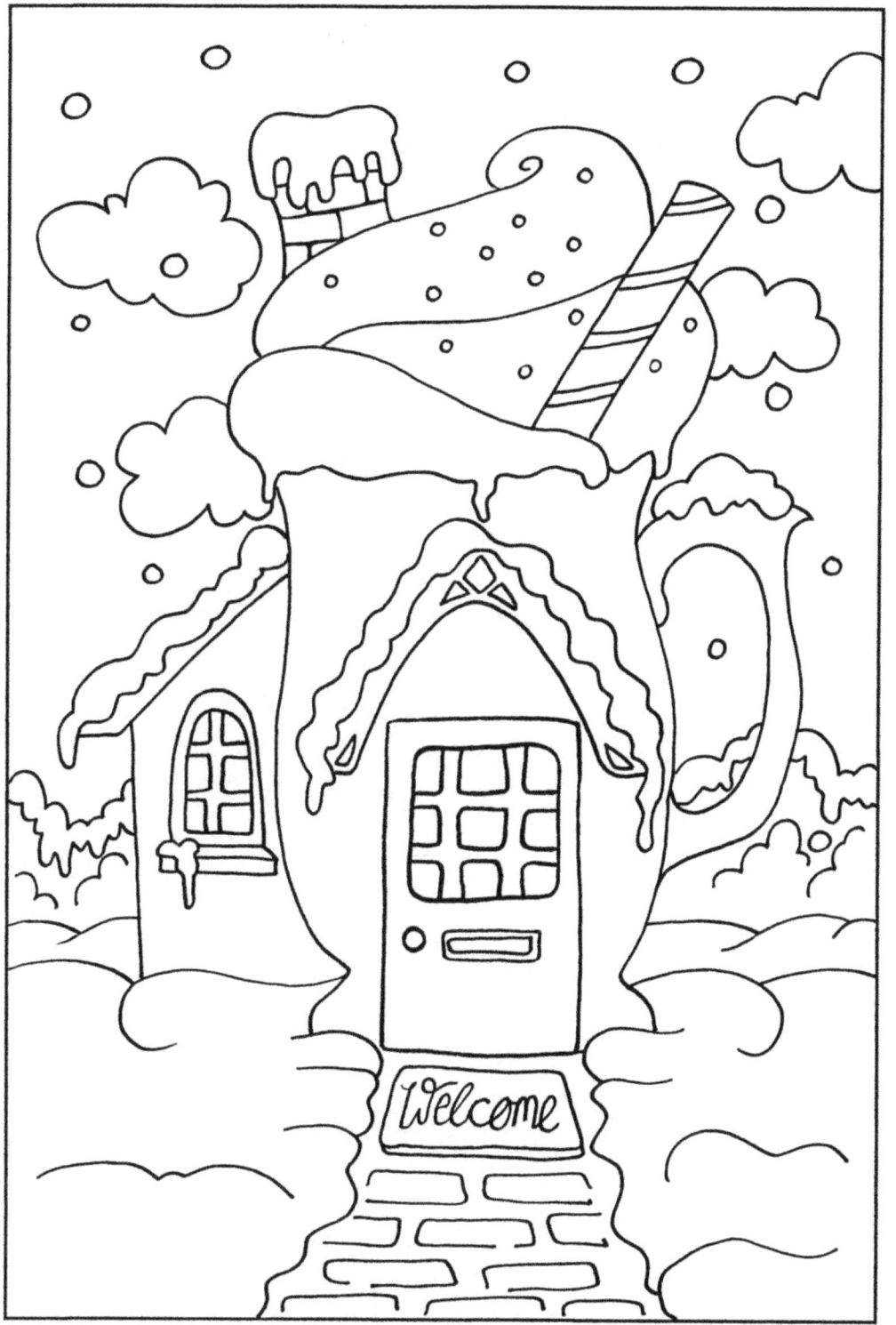

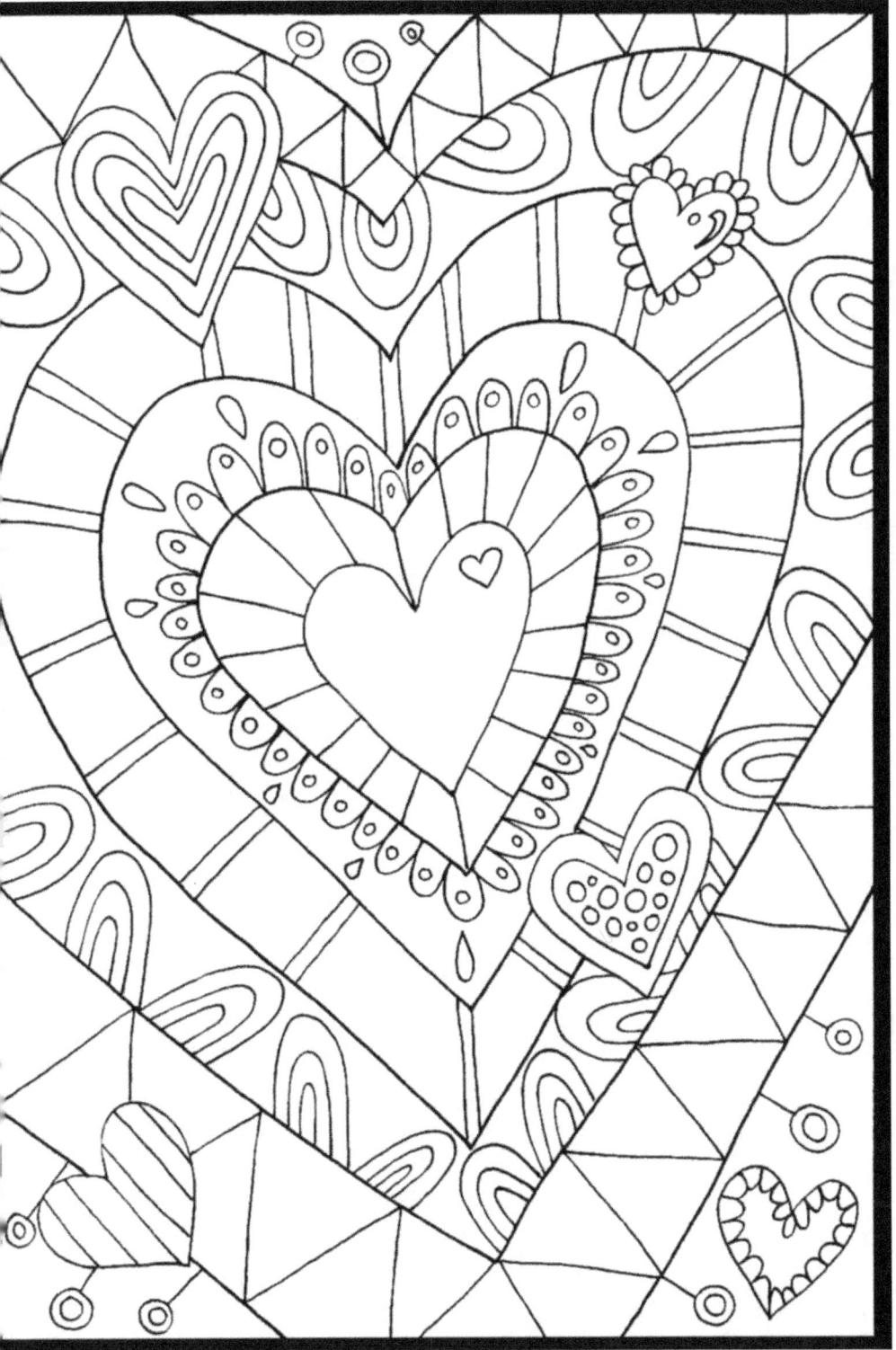

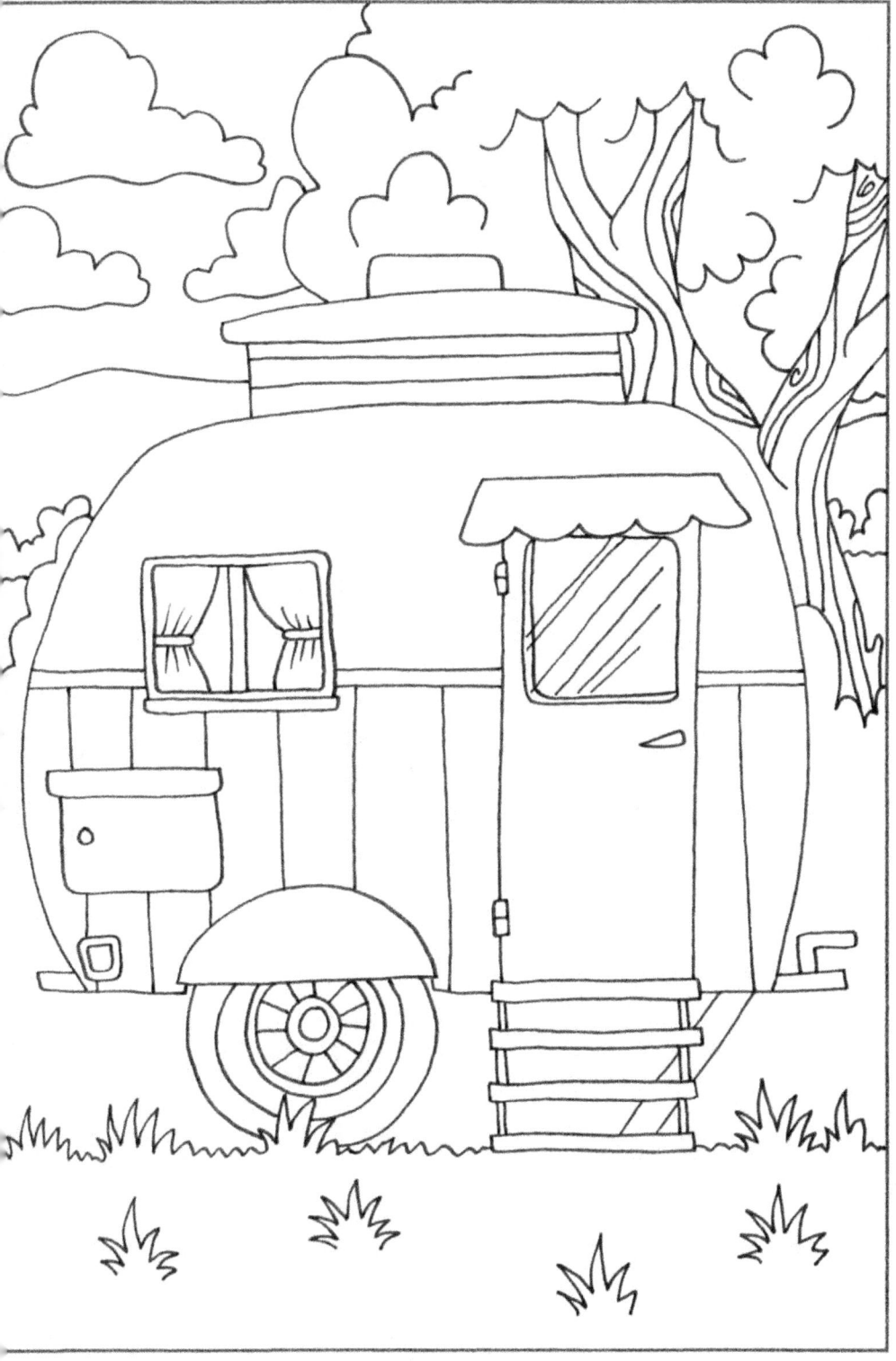

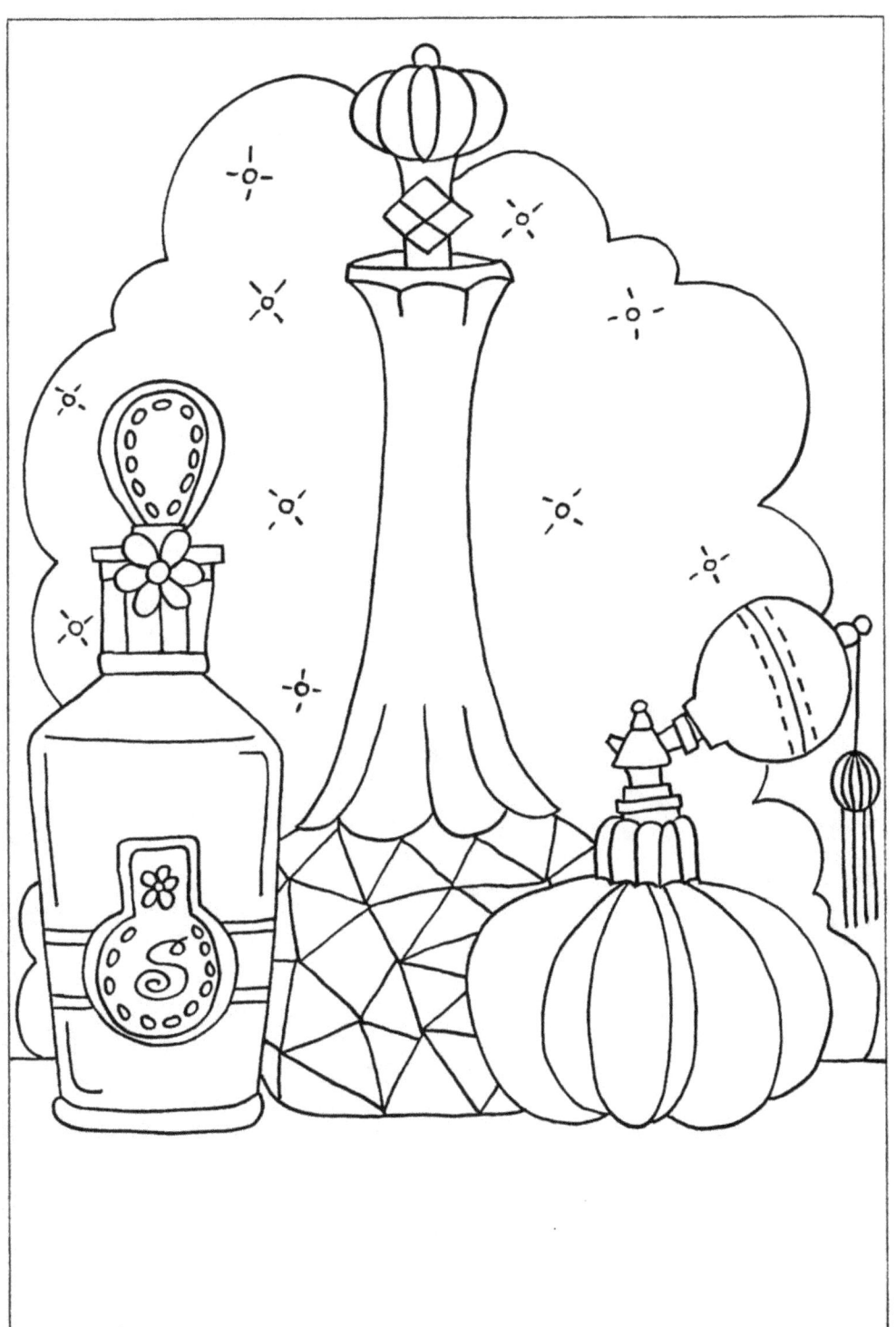

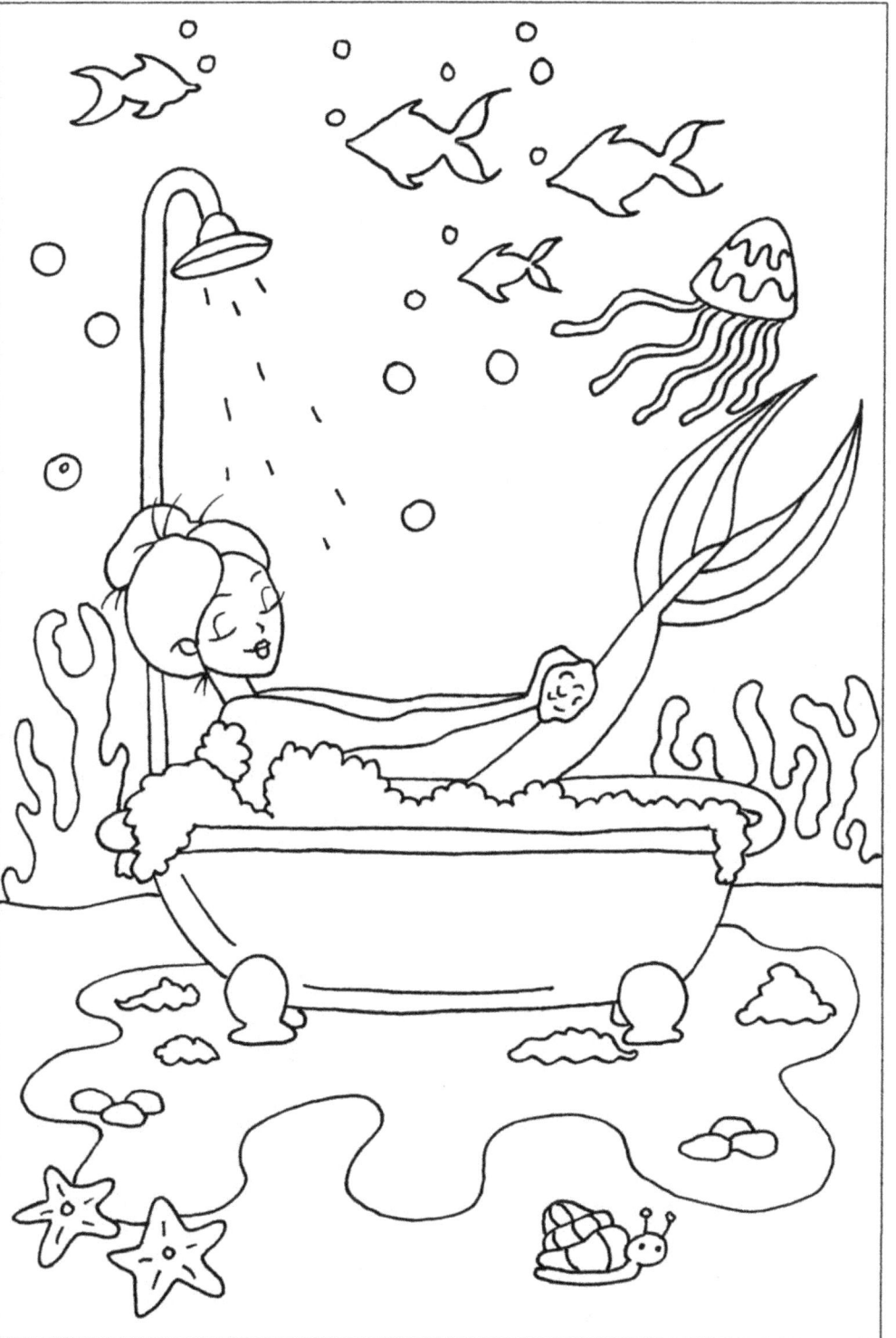

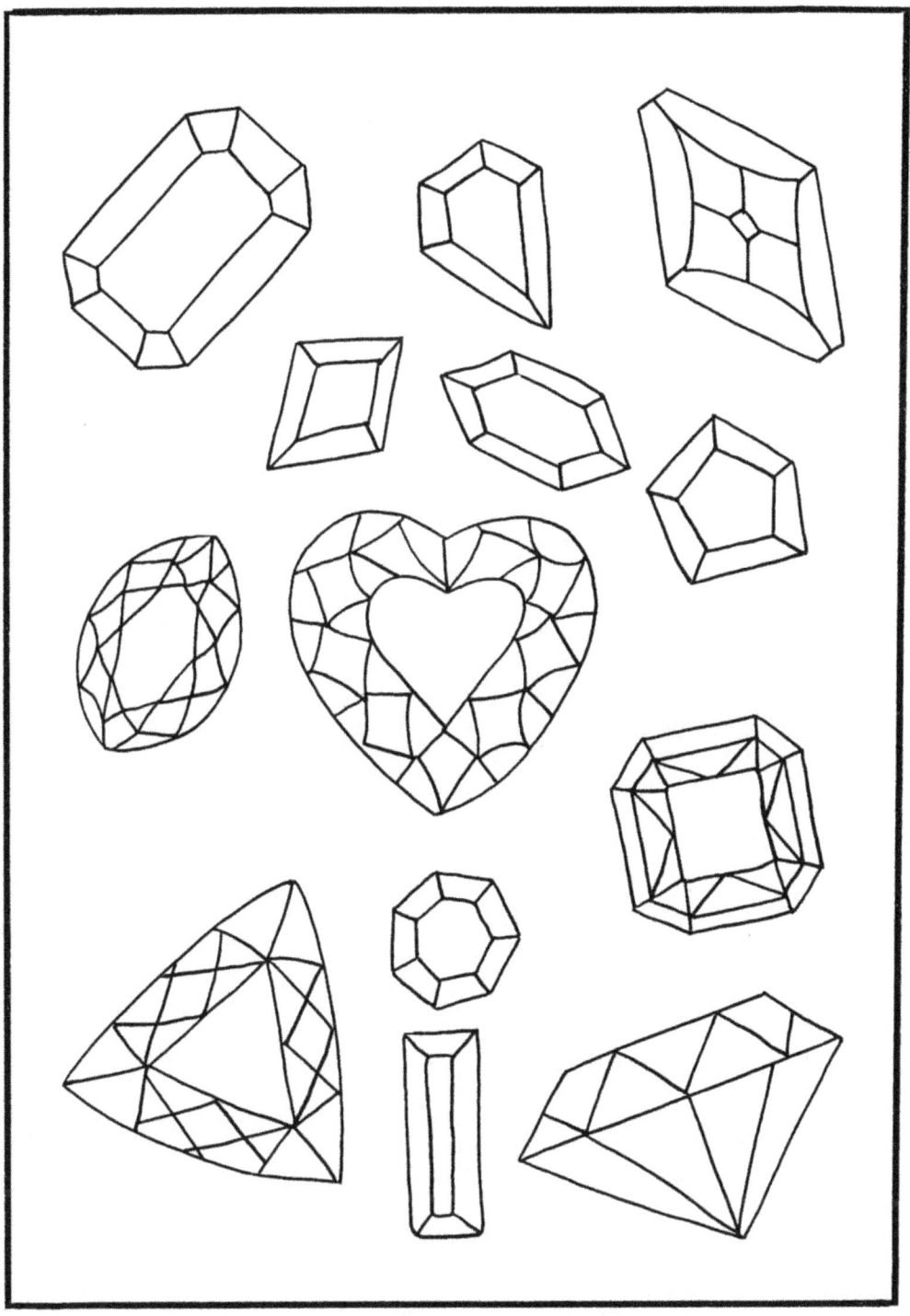

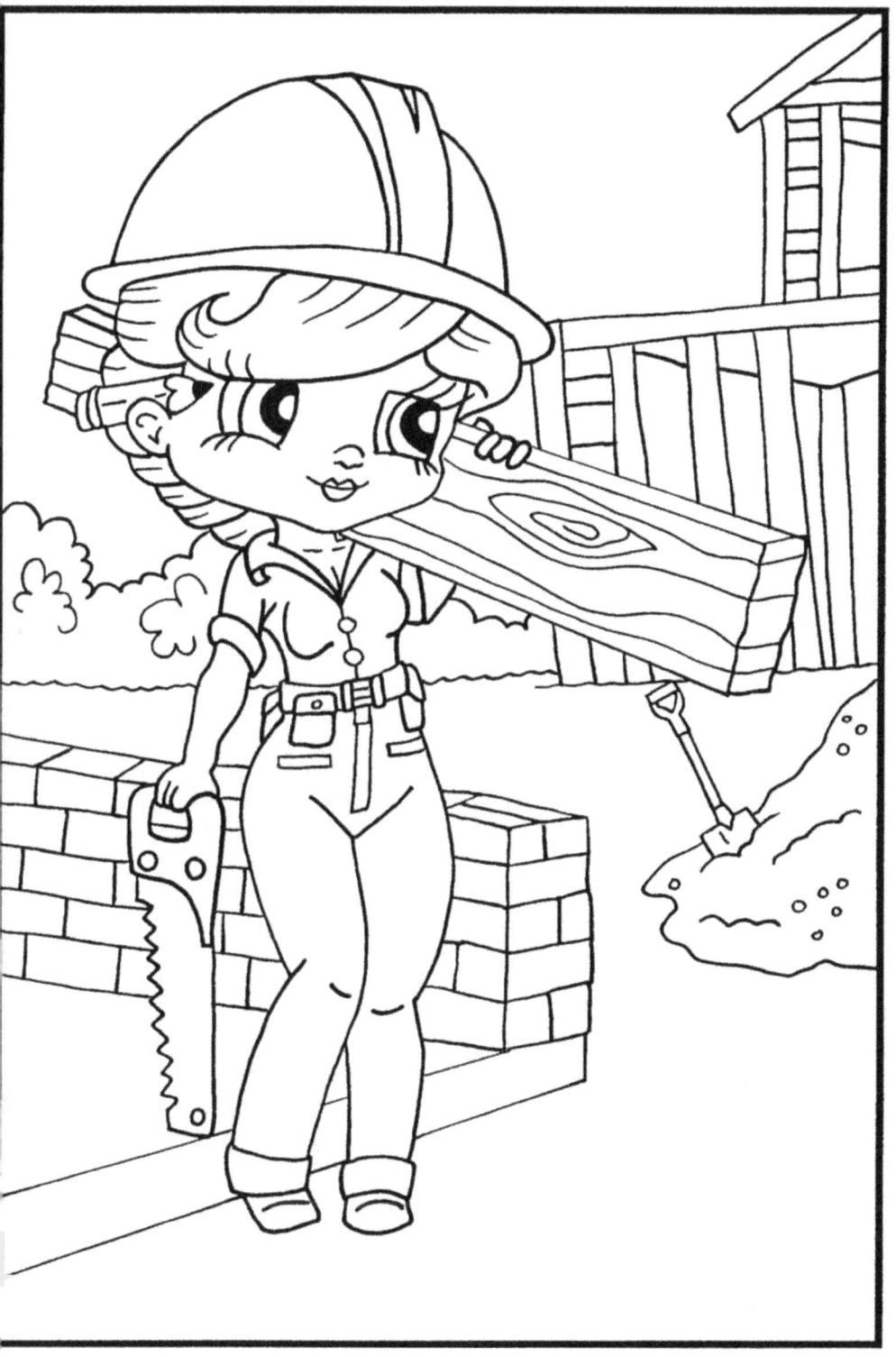

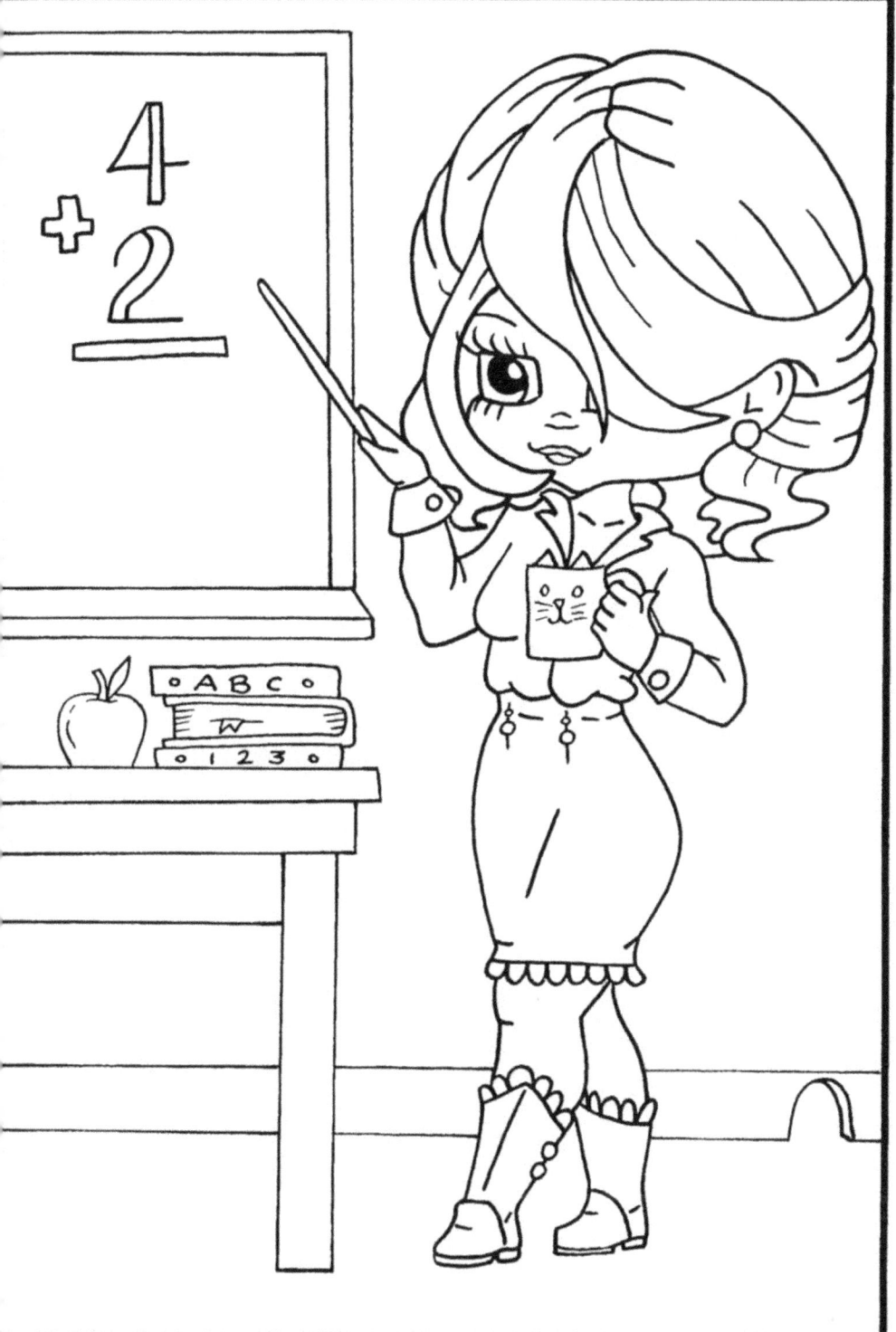

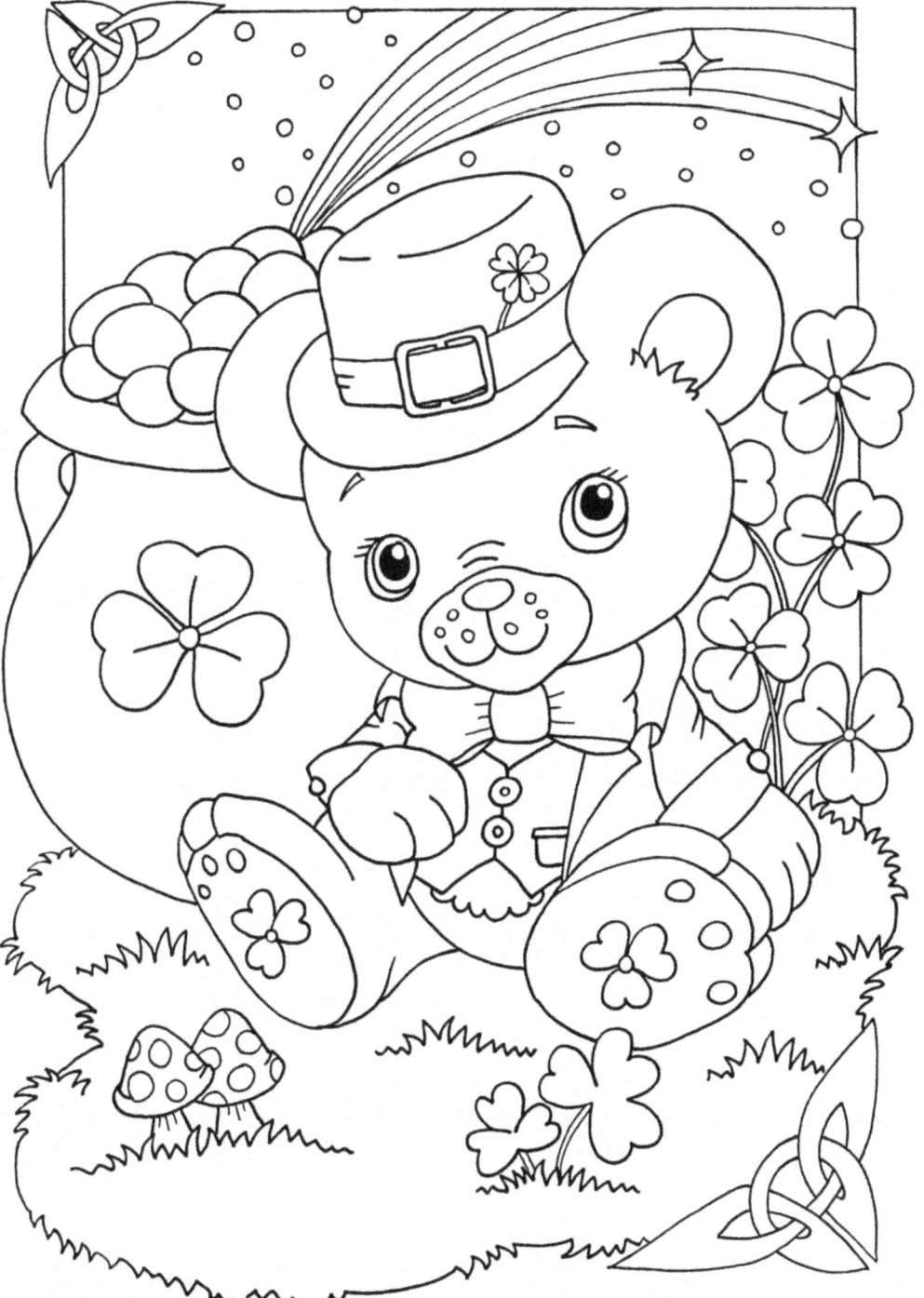

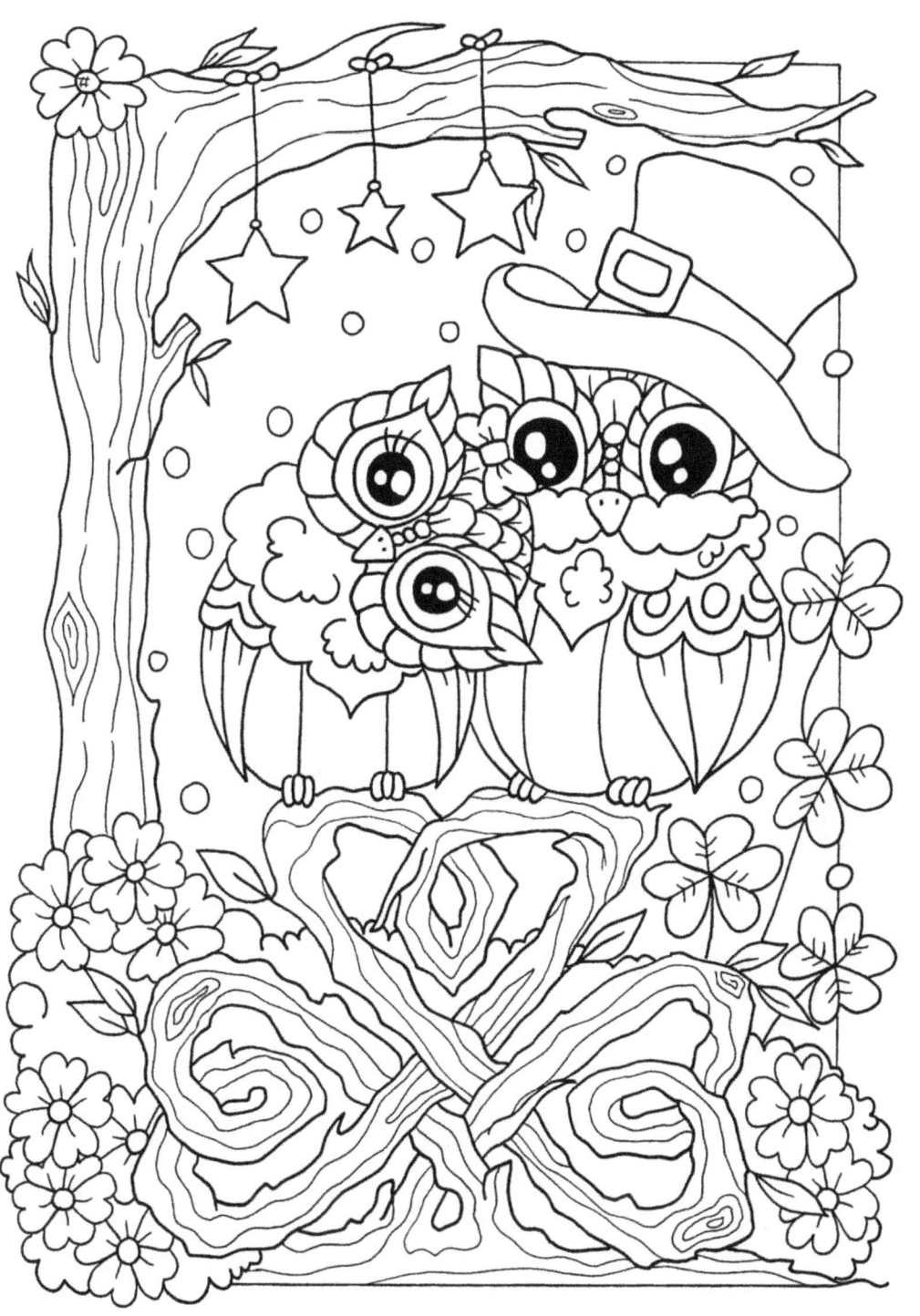

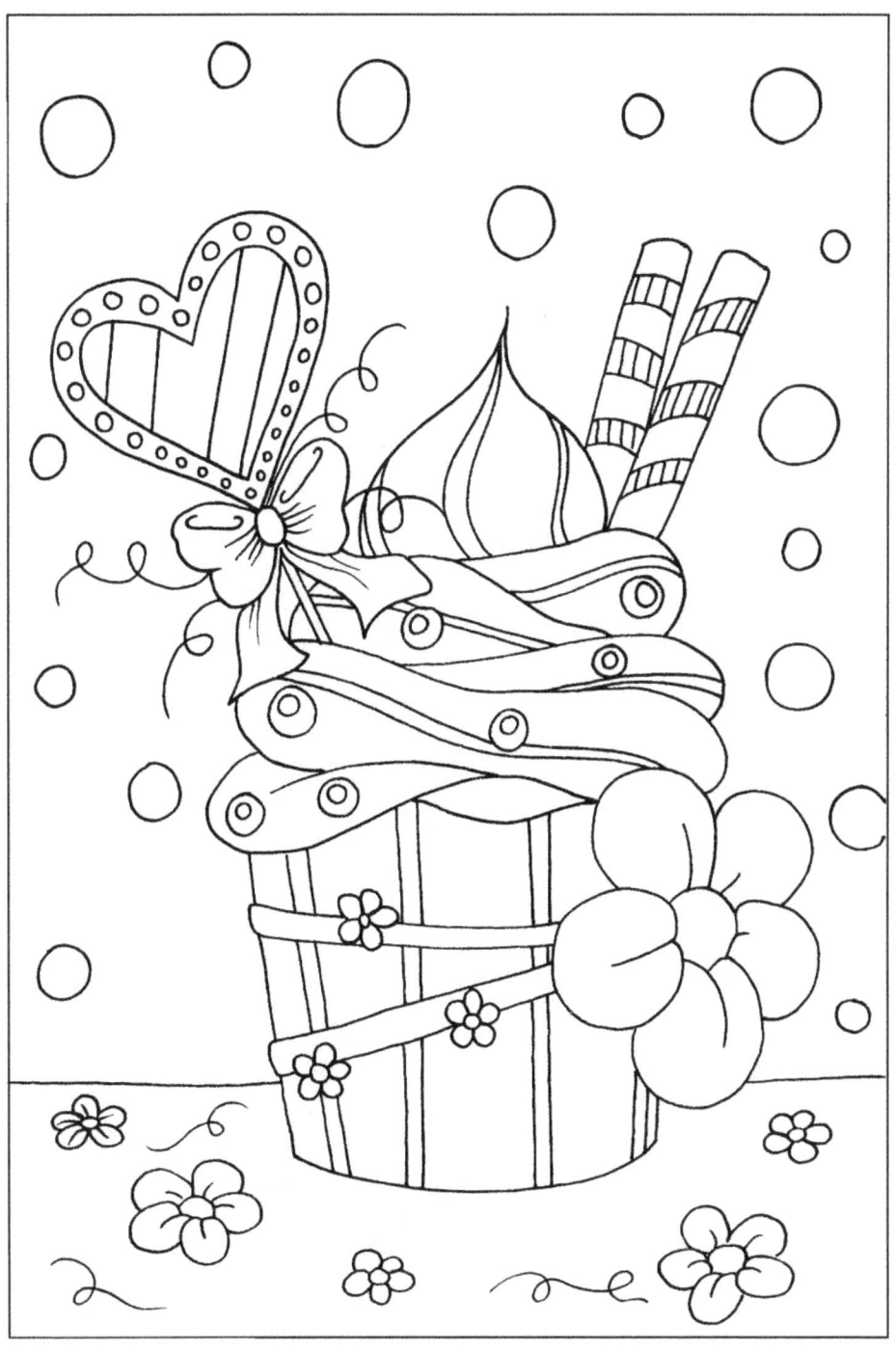

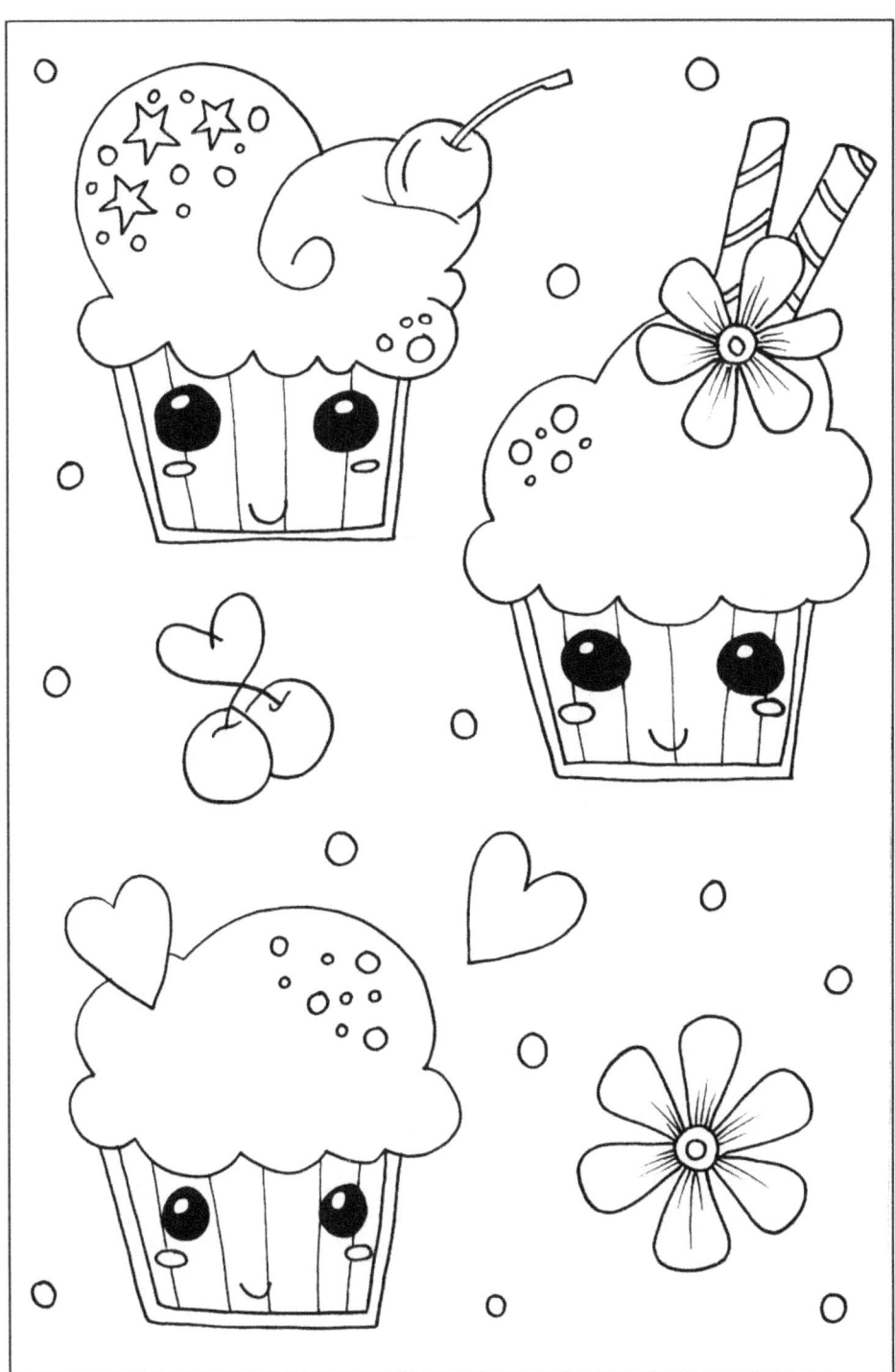

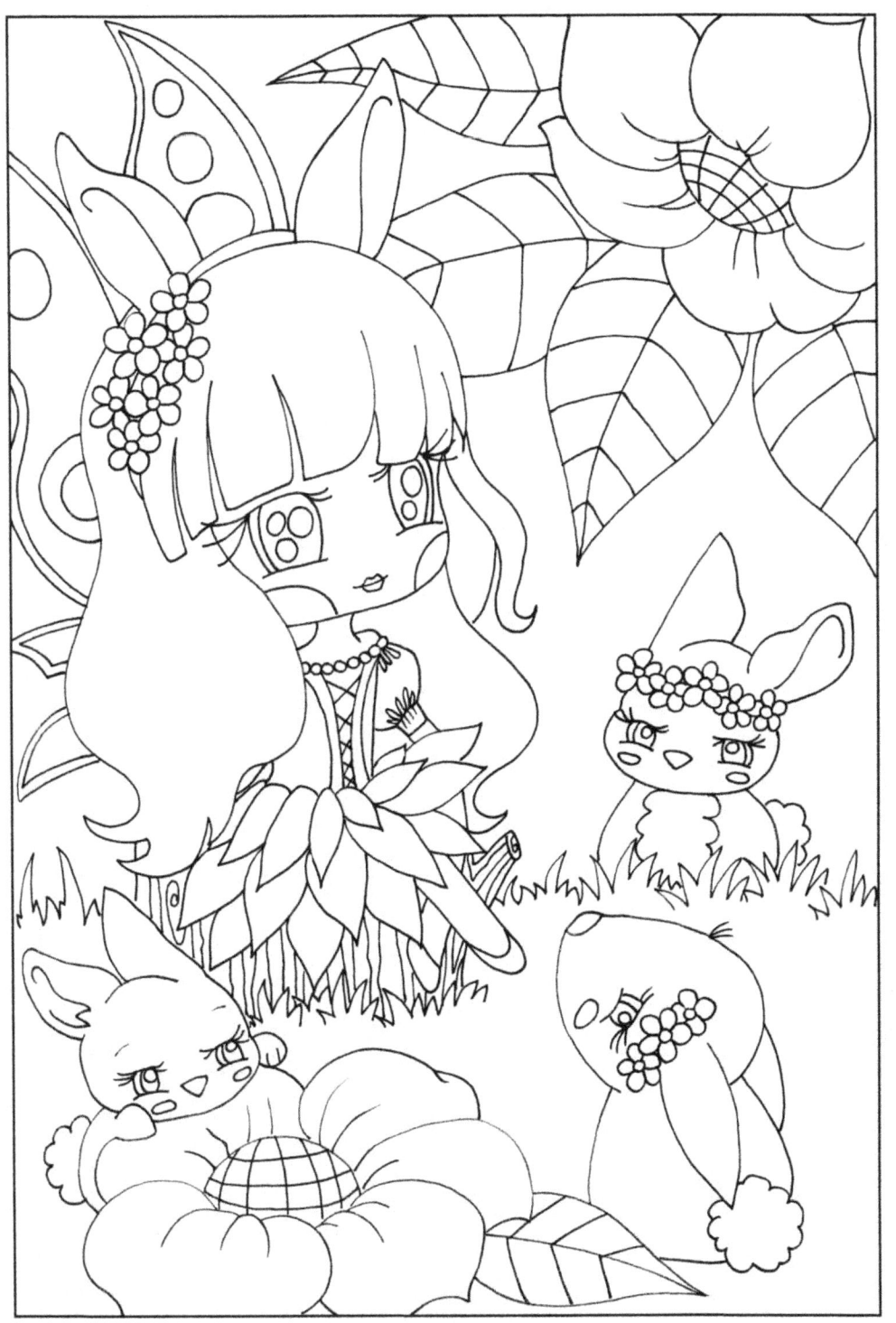

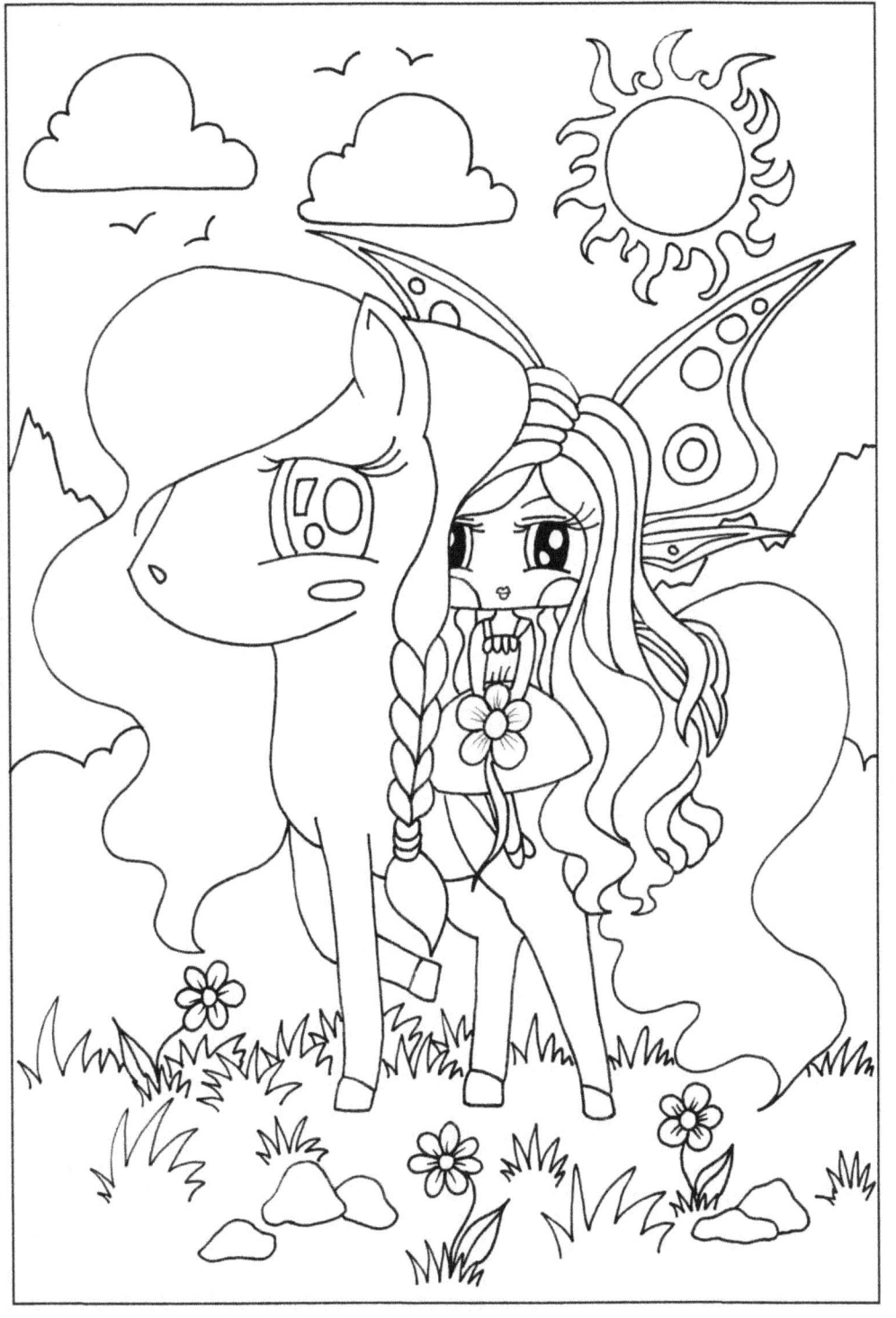

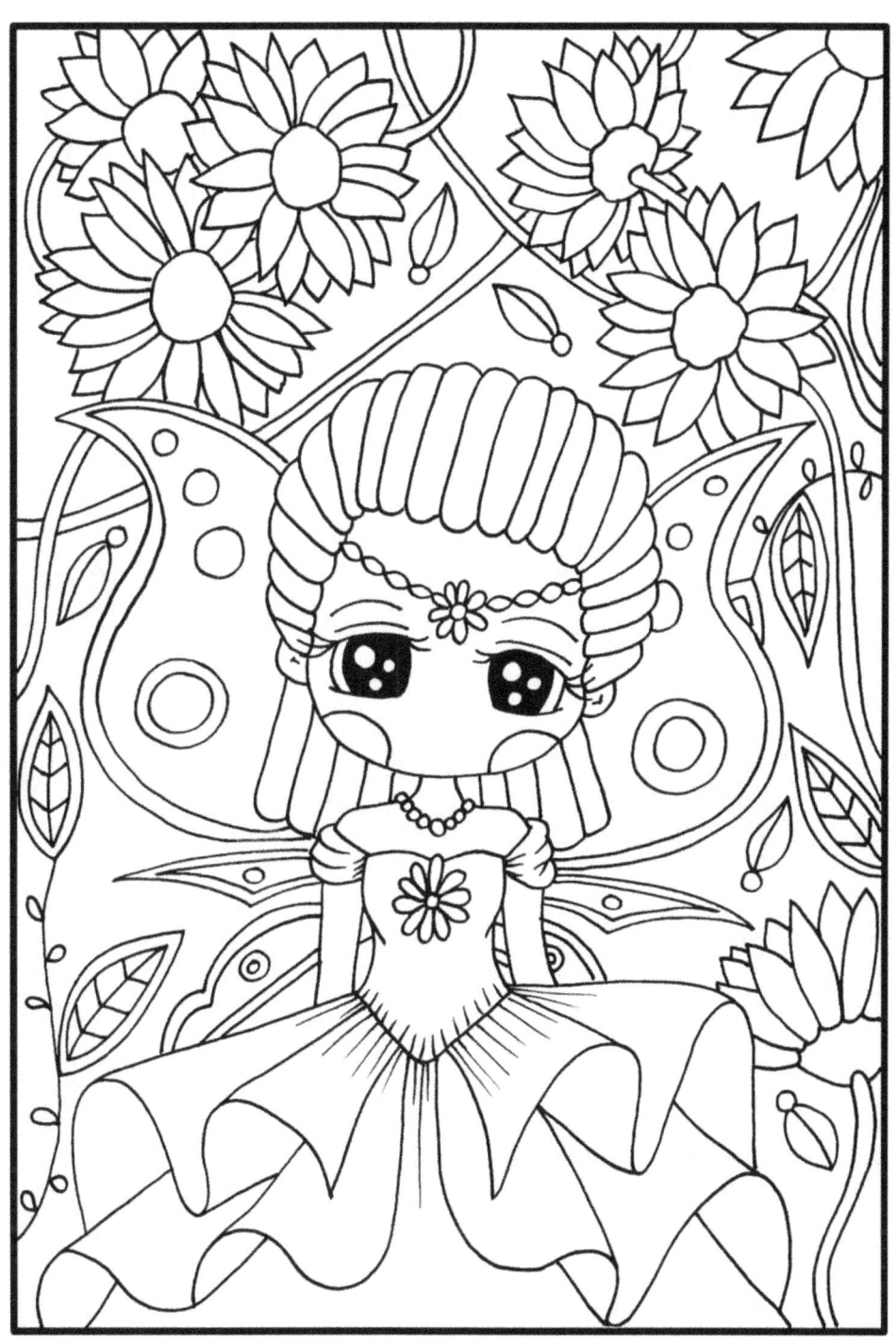

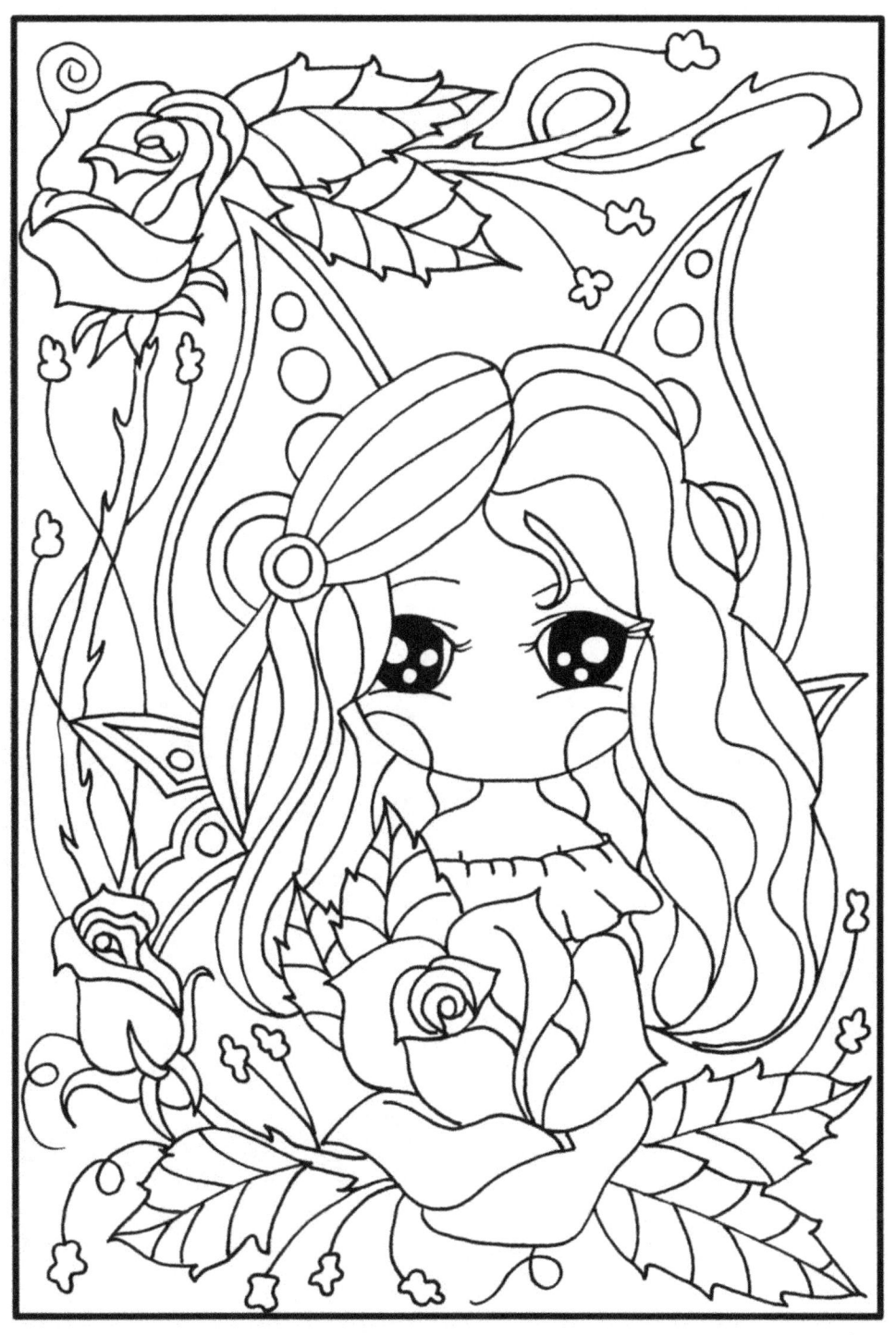

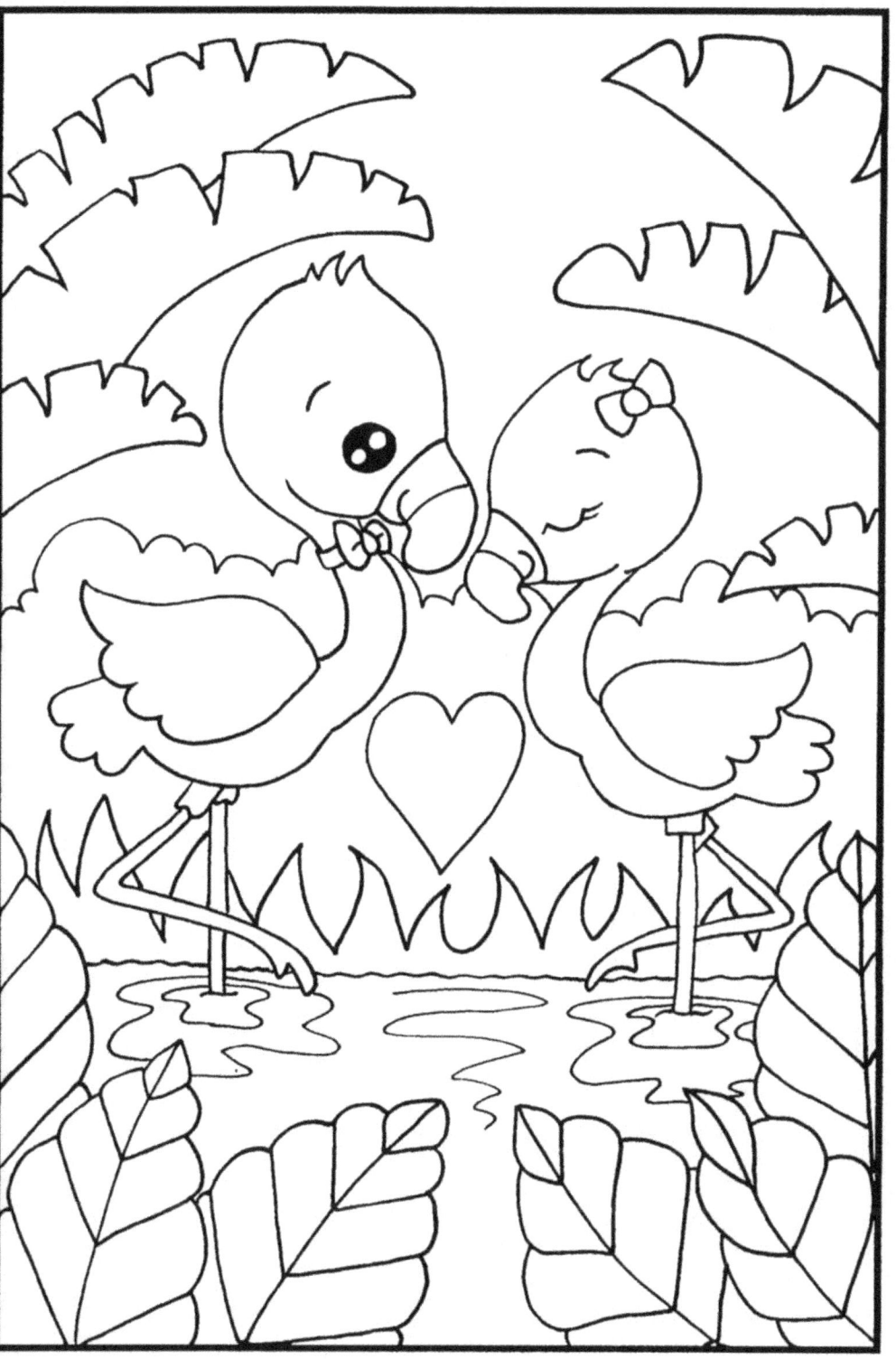

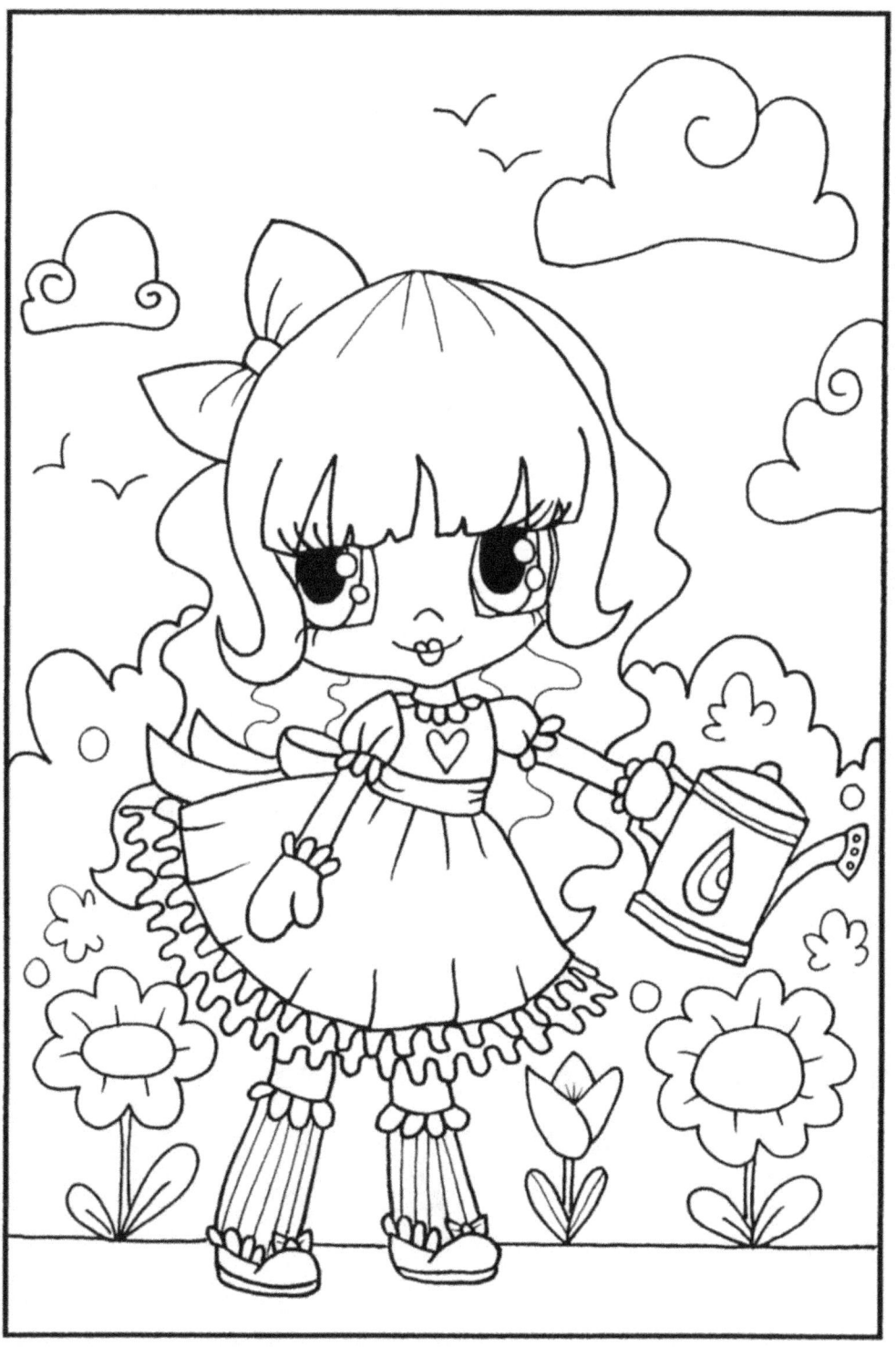

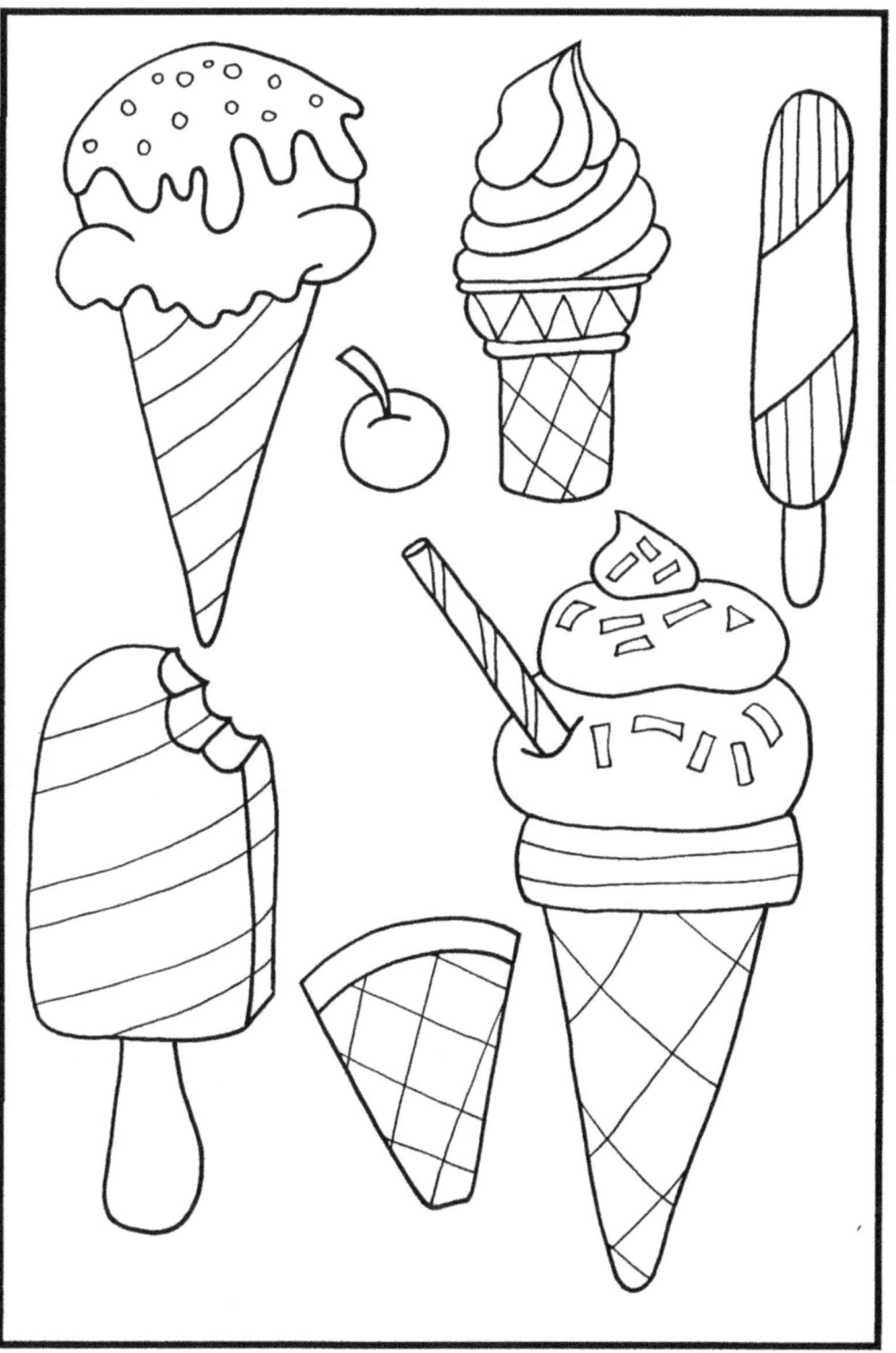

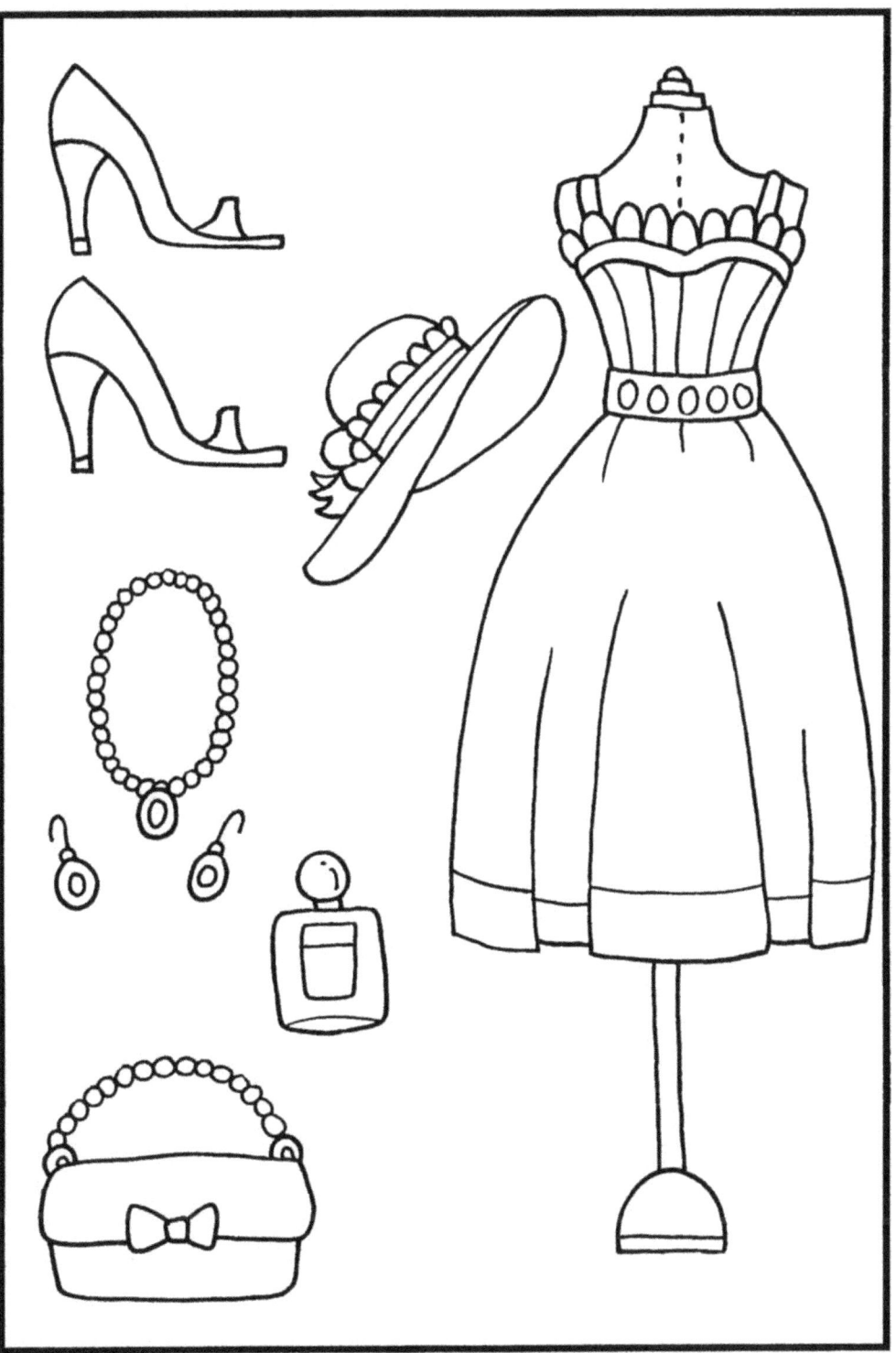

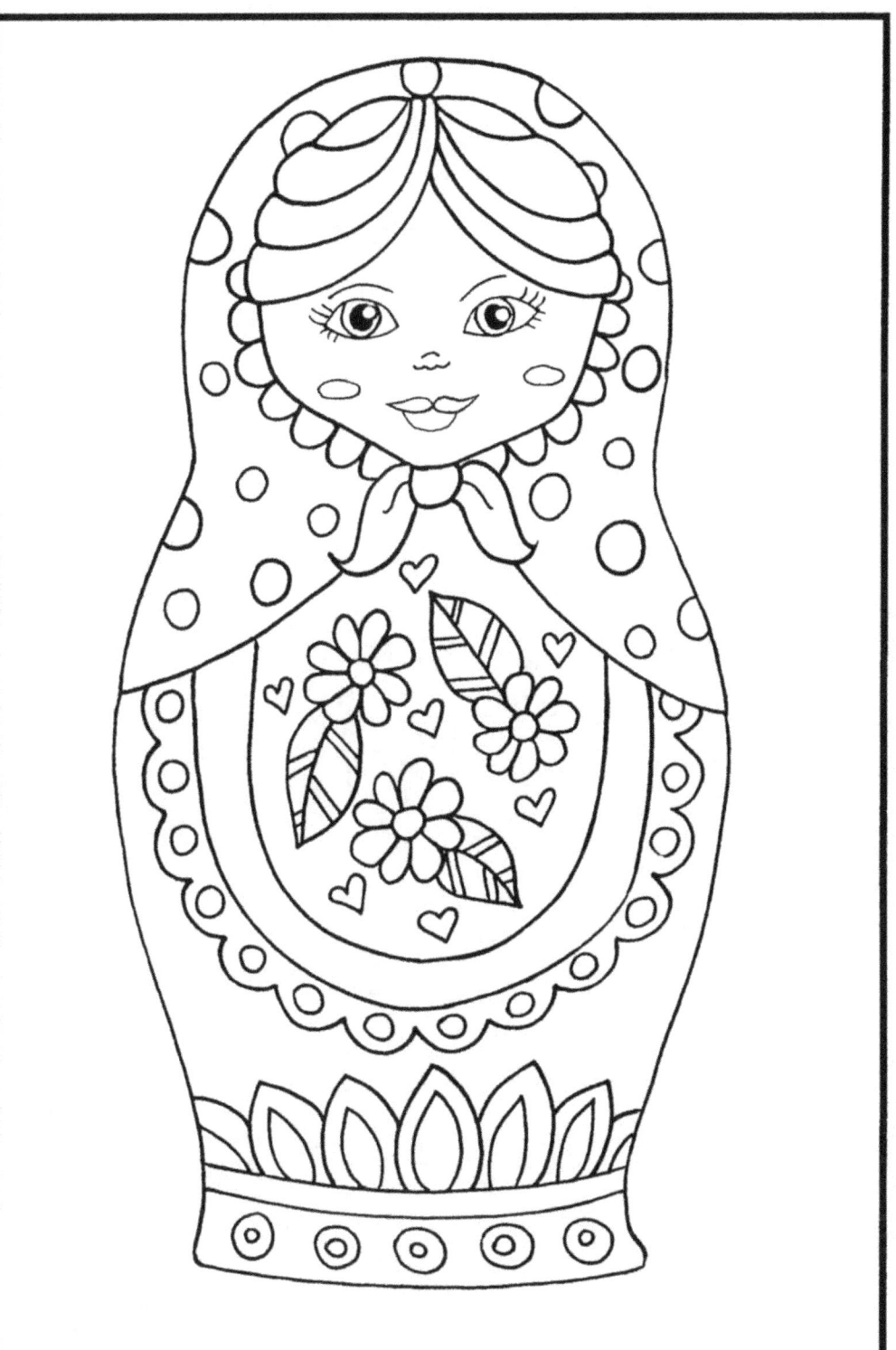

Notes & Doodles

Notes & Doodles

Notes & Doodles

Notes & Doodles

Notes & Doodles

Notes & Doodles

Notes & Doodles

Notes & Doodles

www.ingramcontent.com/pod-product-compliance
Lightning Source LLC
Chambersburg PA
CBHW070437180526
45158CB00019B/1475